Karl Gissing

The Book of Forging

KARL GISSING

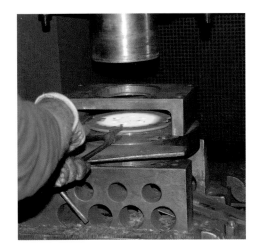 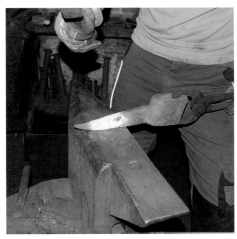

THE BOOK OF FORGING

Basic Techniques & Examples

SCHIFFER
PUBLISHING

4880 Lower Valley Road • Atglen, PA 19310

CONTENTS

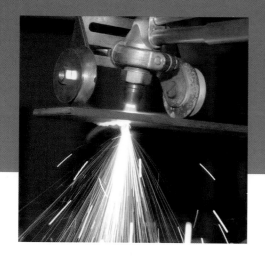

FOREWORD

The Book of Forging presents the traditional handicraft techniques of the smithy. In doing so, I have paid particular attention to making sure that it is possible to use the techniques and make the workpieces presented without having to use too many tools and machines.

In Europe, the number of craftsmen blacksmiths and their smithies has declined significantly in recent decades. In the field of industrial forging technology as well, computerized design and production methods have long since been implemented and have contributed to the fact that we can manufacture ever-better, more complicated, and above all larger forged pieces. Machine operators are often employed to work on the forging press and forging hammer, and they do not necessarily have to be skilled blacksmiths.

However, as for the basic forging process itself, little has changed: we have to move and re-form red-hot workpieces by using great forces. The environment is loud and dusty and fire scale falls from the workpieces.

For a long time it has seemed that traditional blacksmithing might be forgotten. But it is this rough work and the red-hot steel that fascinates many people and inspires them to try this occupation out for themselves. For many young people who have completed technical training, the forging workshops are among their favorite workshops. Forging demonstrations and forging performances can even get children enthusiastic about forging.

In this book, I try to convey the foundations of forging with hammer and anvil. I deliberately left out the use of power hammers, since it is difficult, if not impossible, to use these machines in the private sector or for demonstrations. If they are available, they make handwork easier and make it possible to fashion larger forged pieces.

On the basis of simple examples, I give suggestions and instructions for making forged pieces. These forgings were made without using any machinery and with just a few blacksmith's tools. Starting from these relatively simple works, you can design even more complicated workpieces.

The more you are engaged in forging, the more you keep a look out for the many smithies in our surrounding areas. You can get many suggestions for your own ideas from them.

In addition to the description of basic forging techniques, one chapter is also dedicated to the materials. At the same time, I attempted to reduce this very extensive area of knowledge, in a simplified way, to the requirements for making simple forged pieces.

The chapter "Forged Tools for Agriculture and Forestry" specifically goes into how to manufacture these tools. For a long time, this area was an important part of the blacksmith's work. Almost every village had a smithy shop where tools were made and repaired. These blacksmiths were also responsible for shoeing the workhorses. Many of these smithies have reoriented themselves and are now making machine parts, or working in steel construction, while others have closed down shop completely.

Some of the remaining companies in the forged-tool business have kindly provided knowledge and images for this book.

In many technical schools, forging continues to be taught with great success in training workshops, including in "my school," the Höheren Technischen Bundeslehranstalt und Fachschule (Higher Technical Educational Institute) in Kapfenberg in Styria, Austria. The support from active and retired colleagues from this school was a great help in the evolution of this book. Many thanks for this!

Karl Gissing

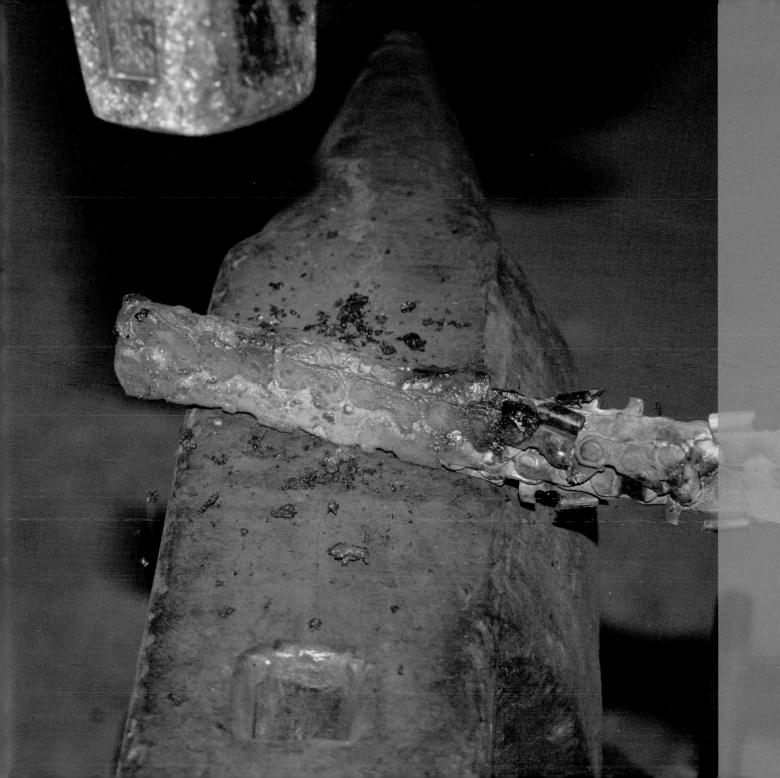

Forging is a process using reshaping techniques for metals. Using a blow (hammer) or pressure (press), the workpiece, usually in a red-hot state, is formed into a desired shape (hot working). Cold-working processes are also commonly used, but this book does not deal with them. Alternative methods for forging are casting (cast iron, cast steel) and machining, such as twisting and milling. Forging and casting, especially the casting of steel, are almost equivalent in some applications, but each process has its advantages and disadvantages. Forging has two important advantages over the machining processes: the properties of the basic material are improved, and it is possible to save on materials.

The History of Forging

With the discovery of metals, the issue of how to form them arose very quickly. Archeological findings from the Copper Age, such as chisels and axes, date from around 8,000 BCE. At that time, only copper, which existed as a solid, could be worked by "forging." Copper is very soft in this condition and quickly becomes blunt. Only with the development of the casting technique was it possible to manufacture workpieces with alloying elements (brass through a content of zinc, or bronze as a copper-tin alloy) and thus obtain better mechanical properties. The iceman "Ötzi," found in the Ötztaler Alps in Austria, who lived around 3,300 BCE, already had a cast copper hatchet with him.

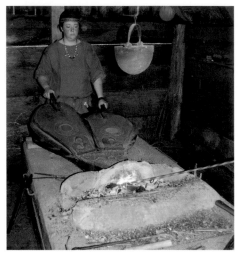

Operating the bellows in a historic forge in the Viking Museum in Ribe, Denmark

You only have to imagine what it would be like to use a copper hatchet or knife to do any kind of cutting!

Humans were first able to make substantial improvements in these material properties only during the Iron Age. Tools and weaponry were the driving force behind this development, and there were big regional differences. In Asia, especially in India and China, people were technologically far ahead of the West. Favorable places for the emergence of forge workshops were those with ore deposits, those with the potential to use waterpower, and those that had fuel available, such as charcoal.

The samurai swords of Japan gained a high level of recognition. These swords are

Portable wooden forging furnace with two hand-operated bellows. The bellows were operated by a smith's helper. Using inverted suction-pressure movements, it was possible to produce a relatively constant air current. *Source: Ribe Viking Museum, Denmark*

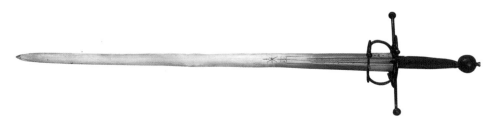

Photo of a sword from the period of 1580–1620, exhibited in the Joanneum Universal Museum, the State Armory in Graz, Austria. *Photo provided by the museum*

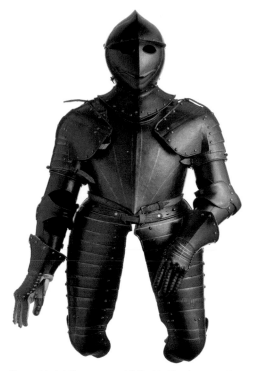

Forged knight's armor, exhibited in the Joanneum Universal Museum, State Armory in Graz. *Photo provided by the museum*

characterized by their very special quality and are still manufactured in a traditional way. European legends also feature famous swords: the sword Excalibur of King Arthur, which is supposed to lend supernatural powers to the sword bearer, and Siegfried's sword Balmung from the Nibelungen legend.

Forging is one of the oldest methods for shaping metals, and it follows that the occupation of a blacksmith is also one of the oldest crafts. In the course of millennia, many specialized disciplines were established, such as the blacksmith, the knifesmith, the ornamental metalsmith, and other related occupations. Many of today's metalworking companies emerged from forge workshops.

Of great economic importance are industrial enterprises for forging highly stressed machine parts. One example we can mention is forged parts for aircraft. These must ensure a high level of operational safety, which is achieved by using forged workpieces. Turbine blades for engines must be manufactured with extreme care, since were this machine part in an aircraft turbine to break, this could cause the most severe damage, which can lead to an aircraft crash. Many museum forges attempt to go into the forging techniques of the past. This is done with particular success at the Viking Museum in Ribe, Denmark.

Forging Techniques

The following remarks are oriented toward processing steel at high temperature (hot working). The workpiece is plastically (permanently) reshaped in this state. For cold working, you must always take into account that you have an elastic area (a bent workpiece springs back around the elastic area).

The blacksmith's work starts by heating the workpiece up to forging temperature. As the steel's carbon content increases, the temperature required for forging decreases. Red-hot steel or iron surfaces react with the oxygen in the air, forming an oxide layer called scale or fire scale. If this scale layer is beaten into the workpiece with blows from a hammer, it causes the workpiece's mechanical properties to deteriorate.

A carbon content of 0.8 percent yields the lowest forging temperature for steel. It is still possible to deform the metal permanently at below the minimum forging temperature, of course, but this involves cold working.

Note: It is even possible to deform the metal permanently at room temperature, but the force required for shaping it increases considerably, and elastic springback occurs.

As a result of heating, the amount of force required for reshaping the workpiece drops sharply, and the material can be plastically deformed with relative ease.

The maximum levels for forging temperatures for steel range from 1,922°F to 2,462°F (1,050°C–1,350°C) and depend on the carbon content of the steel.

Carbon Content	Highest Forging Temperature
0.1%	1,350°C
0.2%	1,320°C
0.5%	1,240°C
0.8%	1,150°C
1.2%	1,050°C
1.5%	1,050°C

Benchmarks for the highest forging temperature for carbon steel

At higher temperatures, steel has characteristic colors that allow for a sufficiently precise assessment of temperature. The annealing colors are important for hot working and the tempering colors for tempering after hardening. Annealing colors are not affected by the carbon content.

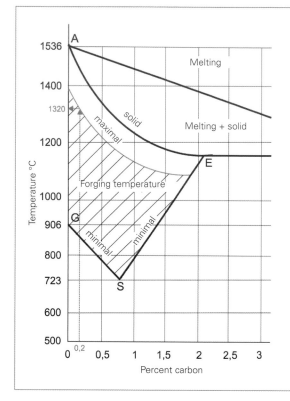

Detail from the iron-carbon diagram. Minimum and maximum forging temperatures depending on the carbon content. Example: with a carbon content of 0.2 percent, the diagram shows a minimum forging temperature of about 1,598°F (870°C) and a maximum forging temperature of 2,408°F (1,320°C).

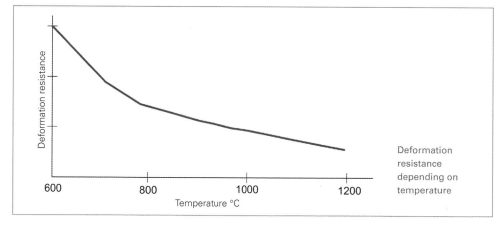

Deformation resistance depending on temperature

ATTENTION: Excessive Heating

If the workpiece is heated too high, the heat can destroy it. If the forging piece is overheated, sparks are sprayed out from the workpiece *(see figure at right)*. The iron burns to form iron oxide. The surface looks porous. Burnt pieces must be cut off

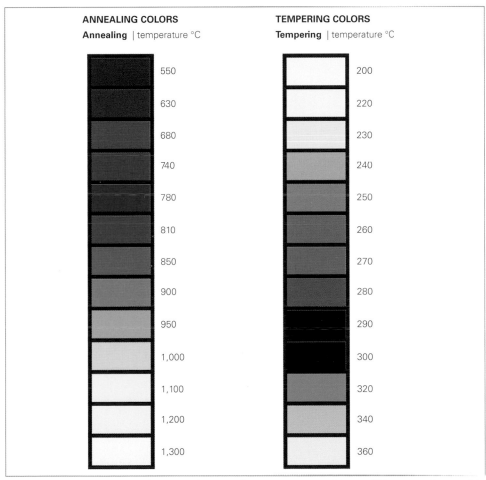

ANNEALING COLORS		TEMPERING COLORS	
Annealing \| temperature °C		**Tempering** \| temperature °C	
	550		200
	630		220
	680		230
	740		240
	780		250
	810		260
	850		270
	900		280
	950		290
	1,000		300
	1,100		320
	1,200		340
	1,300		360

The annealing and tempering colors show the approximate temperature of the steel. The colors change with alloying the steel. The color effect also depends on the surrounding light conditions.

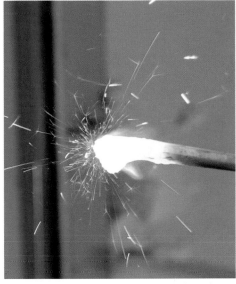

Overheated workpiece: the steel "burns," sparks spray out, and the workpiece is deformed downward by gravity without the application of any external force effects. The burned part is no longer usable and must be cut off.

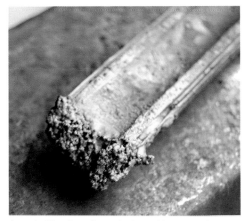

A cooled forging piece, destroyed by excessive heating

Free-Form Forging and Drop Forging

Free-Form Forging

The oldest type of forging is called free-form forging. The starting material is usually a steel bar with a round- or square-edged (rectangle, square, hexagonal, etc.) cross section. The workpiece is fashioned by making targeted hammer blows on the red-hot workpiece, which is lying on a heavy metal base, the anvil. This is how a round bar, for example, is made into an ornamental object, a knife, a pair of tongs, etc. Each similar workpiece is completely handmade and therefore not completely identical to any other. The process is time consuming, requires physical effort, and is therefore costly. Free-form forging also corresponds broadly to the popular idea of forging: a dark, sooty workplace with coal fire, red-hot workpieces, and the loud hammer blows by the black-

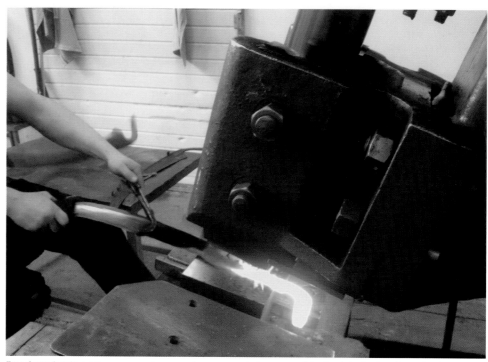

Free-form forging using a power hammer (compressed air operated) in the Schadenfreude scythe factory. *Source: Franz de Paul Schröckenfux GmbH*

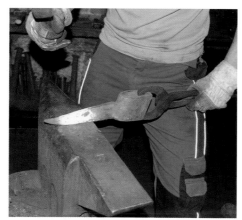

Free-form forging a large workpiece. When the weight of a workpiece is greater than human strength, a manipulator tool is used to hold and move the workpiece. Heating is usually done in a gas-fired furnace. To reach even heating, heating time can take up to one hour. Free-form forging is often used as an initial step for drop forging (*far left*).

Classic free-form forging with hammer, anvil, and tongs. Forging a sappie to be used for forestry (*left*). *Source: Feiner GmbH*

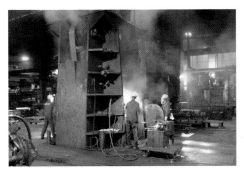

Forging press for industrial production of large forged workpieces

Die half with welded-on sections. Welding on wear-resistant materials significantly increases the service life of the die. *Source: Krenhof Aktiengesellschaft*

Parts forged in a die. These still have to be machined to give them an internal thread and are used in the construction industry. *Source: Krenhof Aktiengesellschaft*

smith. These are usually represented as strong and likewise soot-blackened men.

Very large workpieces, such as shafts for power station turbines, are fashioned on large forging presses or forging hammers before they are brought to their final shape by chipping.

Drop Forging

This is a forging process that is often used in industrial production. Two mold halves made of steel, which are worked into the shape of the workpiece (die), are used.

The workpiece that is to be deformed is inserted into one half of the die, leaving some excess, and the second half of the die is set on top. With blows from a sledgehammer or power hammer—the size of the hammer is determined by the size of the workpiece—the die is compressed so that the workpiece takes on the form of the die cavity.

To make sure that the die is completely filled, it is necessary to insert a larger volume than is absolutely necessary. This results in surplus material, which remains as a burr or flash on the workpiece and has to be removed later on.

The die-forging process allows us to attain greater dimensional accuracy and better repeatability (each workpiece has the same dimensions) than if free-form forging

Inserting the preform, heated to forging temperature *Source: Krenhof Aktiengesellschaft*

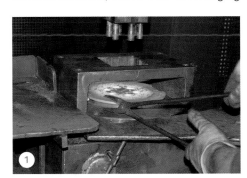

Die-forged pieces with six holes. The die-forged machine piece still has some excess (burr). This is cut off by using a punching tool while the workpiece is red hot. *Source: Krenhof Aktiengesellschaft*

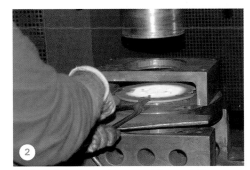

Cutting off the burr with a punching tool. *Source: Krenhof Aktiengesellschaft*

Simple die for die forging a ball. The two die halves are held in position by a bent piece of flat steel and held open by the spring action of the bent flat steel.

is used. Manufacturing dies are expensive. The process is therefore worth it only for a large number of pieces.

Cold-Work Forging

Forging machines are used for commercial and industrial production; these can mainly produce simple bars by twisting and bending. The machines mostly shape the bars when cold, which also prevents scaling. Bars produced in this way are easy to recognize, since they are completely uniform on the surface and there are no visible hammer blows. For bent parts, at the start of the bent section there is usually a small straight part, due to the place it was fixed. These objects are generally made of relatively thin wire or flat steel, so that the force needed to deform it is small. The main advantage of this manufacturing method is the low price.

Industrial Forging Techniques

As is the case for all processes for making workpieces industrially, computerized methods are also used in forging technology. Computerized methods for designing and calculating components are state of the art in mechanical engineering. In forging, computerized methods are used mainly for simulating the flow processes for drop forging, determining the required force and necessary heating processes. Simulation of the forging process makes it possible to detect weak points and eliminate them at an early stage. The die is designed only after successful simulation of the forging process and according to the results of the simulation. As a result, any complex reworking can be largely avoided.

Basic Tasks of Free-Form Forging

The basis for these working techniques is the practical incompressibility of the metals. This means that the volume of a workpiece remains the same during the reforming process. The material or the workpiece is reworked only in that its shape is changed.

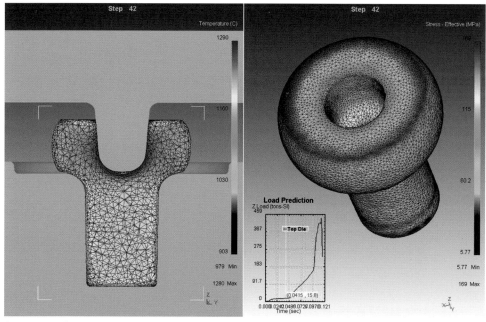

Computerized drop-forging methods can determine flow processes and the force required for forging.
Source: Krenhof Aktiengesellschaft

Any minor changes in the volume, such as due to scale falling off, are irrelevant.

Upsetting

During upset forging, the workpiece is shortened in the impact direction. As a result, the dimension increases perpendicular to the impact direction. The ideal case of a constant-thickness development does not occur because the workpiece cools down on the bearing surface and at the contact points with the tool, causing friction, and therefore it is less deformed at these areas. The result of an upsetting process also depends a great deal on the applied impact energy from the hammer. If the impact energy is too low,

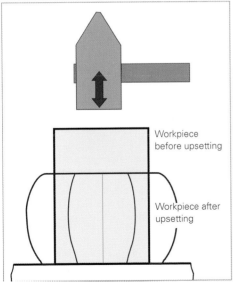

Schematic illustration of a piece during upsetting

exactly the opposite behavior can occur—the workpiece is upset-forged only in the region of the hammer blow.

Example: You want to make a bolt with a cylindrical head from a round bar. To do this, you upset-forge one side of the round bar.

Upsetting Process

During upset forging, the cross section of the area to be upset is increased and the

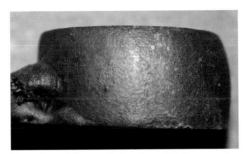

Upset-forged short cylinder piece. At left, a round rod was welded on to make it possible to hold the workpiece better. On the right edge, the typical deformation can be easily recognizable.

Upset-forged cylindrical workpiece. Due to low impact energy, the workpiece was deformed only at the contact surfaces, and the impact energy was insufficient to extend to the center of the workpiece.

length is reduced. The upset place is heated as high as necessary so that deformation resistance is low. In upset forging, you differentiate between upsetting at the end of the workpiece and upsetting between the workpiece ends. The place to be upset should be heated to a very limited extent. If this is not possible, any places that are heated too much should be cooled with water. The hammer blows cause long workpieces to bend easily. It is therefore especially important to ensure that these fall centered and straight on the workpiece. The impact strength of the hammer has to work as far as the workpiece center so that these areas are also deformed. Therefore, you have to use large and heavy hammers. After each blow, rotate the workpiece to compensate for any undesired deformation. The workpieces bent by upsetting must be straightened immediately so that they do not bend further.

Upsetting on an Anvil

Heat the workpiece to forging temperature at the point to be upset, and position it so that it is perpendicular to the anvil face. Strike the blows with a hammer adjusted to the size of the workpiece. If the workpiece is long, it can also be set on the foot of the anvil. There are also anvils for upsetting in use.

Upsetting in a Vise

Clamp the bent bars that are to be upset at the ends in the vise (vertically or horizontally); otherwise the bent part can spring and be additionally deformed.

Upsetting in a Perforated Plate

Upsetting at the end of the workpiece is often only the first step in the upsetting process. In a second step, the upsetting process is completed in a perforated plate.

Flattening

Flattening a forged piece increases the length (width) of a forged piece and reduces the cross section. Blacksmiths do flattening work frequently, and it broadly corresponds to the general idea of a blacksmith's work: the workpiece lies on the anvil and the blacksmith strikes the workpiece with massive blows. In this process, the thickness is decreased in specific areas while the

Flattening an incompletely heated thick-walled forged piece. The outer areas are flattened more than the core.

Flattening a bar on the anvil

length is increased. It is important that the workpiece be evenly heated, which means that the same temperature prevails at the workpiece core as in the outer areas. If not completely heated, the outer areas of the forged piece will deform more than the core.

The easiest way to flatten is to use the peen of the hammer on the anvil or the anvil horn. The hammer peen acts like a wedge and drives the workpiece apart. The sharper the hammer peen, the greater will be the dispersing forces. The remaining "ribs" are

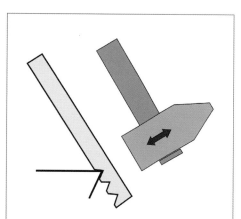
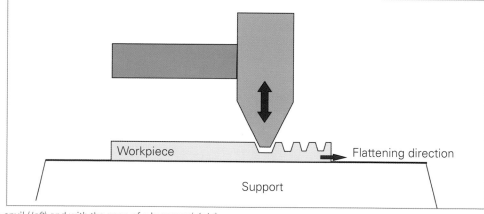

Workpiece

Flattening direction

Support

Flattening a workpiece over a sharp edge, such as on an anvil (*left*) and with the peen of a hammer (*right*)

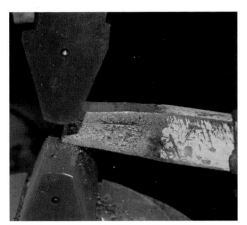

Flattening a rectangular 1.6-by-0.8-inch (40 × 20 mm) cross section with a power hammer. The head and face of a blacksmith's hammer have a rounded shape, similar to the peen of a hand hammer.

Spread round bar with rounded end. The indentations indicate that it was spread using a hammer peen, but here they create a better visual effect.

smoothed out with the face of the hammer, and the result is an additional flattening effect.

The process described above ensures that the flattening goes mostly only in one direction. If the flattening is done on the anvil horn rather than the anvil face, this enhances the flattening process.

The flattening method shown in the figure can also be done over the anvil edge or with other tapered tools that cause the material to be displaced in one direction.

Spreading

In principle this is also a form of flattening but is done perpendicular to the bar axis. This work step is often applied to the ends of ornamental bars, usually in combination with curling the bar ends, by using the notches in the hammer claw or a blacksmith's fuller hammer to especially highlight them.

A fine example of spreading is the old broad axe shown in the picture. These tools were usually made of two pieces—the cutting edge and the housing for the handle, the "eye." This made it possible to use two different types of steel according to the requirements. Both parts were forge welded and the cutting edge was hardened. The maker's information is still stamped on the tool.

Another example of spreading and flattening is in manufacturing scythes and sickles. For these, a relatively thick blank is used, which is largely forged out to less than 1 mm in several operations.

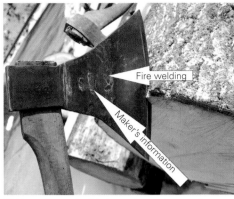

Old broad axe: the blade portion was made from a separate piece.

Forging a scythe. *Source: Franz de Paul Schröckenfux GmbH*

Drawing Out to a Point

Here, the ends of a bar are conically forged outward. The cross section may be round or angular. Examples are bars to be rammed into the ground, nails, and staples used for wood construction, but also tools for gardening and agriculture. Tools usually

require a heat treatment, such as hardening and tempering, after the forging work, as well as sharpening any existing cutting edges. For drawing out, the workpiece is turned 90° after each hammer blow.

Twisting (Torsion)

Twisting bars can create beautiful effects. In mass production such work is done both rapidly and cheaply through cold work on the appropriate machines.

In free-form forging, this work is done at forging temperature, which allows for a great variety of designs.

Particular attention must be paid to the exact heating of the sections to be twisted. The higher the temperature, the lower the deformation resistance, which means that the hotter area gets twisted more—a larger torsion angle—than the colder areas. You can avoid this to a large extent if the twist

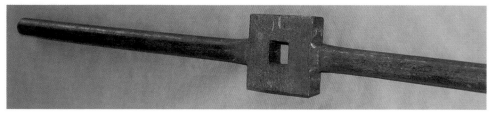

Example of a rigid twisting wrench with a fixed four-edged holder for the workpiece. Such twisting wrenches with different-sized workpiece holders are often found in forging workshops, since they can withstand the heavy strain from forging work.

section is heated evenly and the clamping points are inside the heated section. You can consciously utilize unequal heating to obtain different angles of rotation.

Basically, in this work it is important to make sure that you guide your tool precisely, to avoid having to straighten it afterward. You can think of this in such a way that the "imaginary" centerline of the workpiece is always maintained. The twisting process produces tensile stresses at the outer sections of the forged piece, and in the core of the forged piece, compressive stresses occur. As a result, the forged piece is shortened by the twisting process.

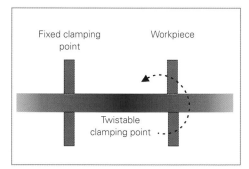

Schematic illustration of a twisting process. The workpiece is at the same temperature everywhere between the clamping points, so that you can deform it uniformly between the clamping points.

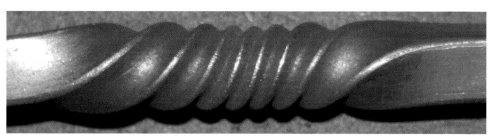

Different twisting due to different heating

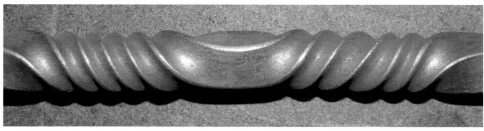

Combined twisting of a four-sided bar by right-left rotation

The fixed clamping point can be a vise, and the twistable clamping point can be a twisting wrench or tongs with a locking device (locking pliers).

Examples of
Different Ways to Twist a Workpiece
In addition to the many possibilities for ornamental and art objects, simple twistings are also required for handicrafts.

After heating, clamp one end of the section to be twisted in a vise and grip the other end with the twisting wrench or a pair of tongs and twist. If you use tongs for twisting, you achieve a one-sided application of force. As a result, the section to be twisted is bent and must be straightened afterward. This can be prevented by using a twisting wrench.

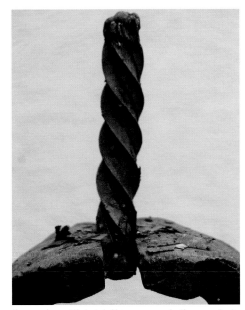

Square bar with twist. This represents the simplest and most common type of twisting.

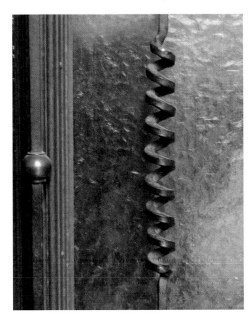

Screw-shaped twisting of a square bar. Window by the entrance door (St. Stephen's Cathedral, Vienna).

The most frequently used technique is the simple twisting of bars with a square cross section. You can create beautiful effects by combining left and right twists. This can be done in cold work with the aid of machines.

To achieve good success in twisting work, it is necessary to heat the sections to be twisted evenly. By using targeted uneven heating, you can create more or less sharply twisted sections.

If a bar is notched in the middle before twisting, this creates an effect after twisting that is similar to a split bar.

Notched square bar. The notches can be made with the flat chisel or with a splitting hammer. The difficulty lies in guiding the notching tool exactly along the center.

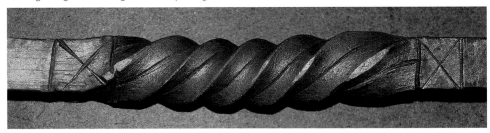

Notched square bar after twisting when heated. At the end of the twisted section, notches were added to improve the visual effect.

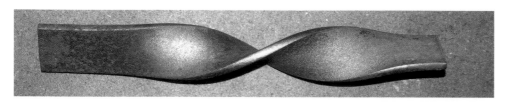

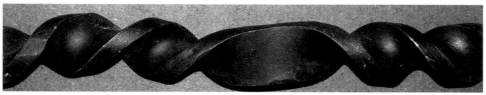

Twisted flat bars

In addition to square bars, other cross sections are also used for twisting.

Bars are often twisted to make basket twist decorations. This method is described elsewhere in this book.

Bending

When bending bars, for example to make a right angle, a bender radius necessarily results. This is because the inner side of the bar is compressed and the outer side of the bar is subject to tension. In the middle is the neutral axis, or neutral fiber, which is neither compressed nor stretched. In many cases, however, you would like to have a sharp edge. This requires compression in the bending area, since stretching of the outer side weakens the cross section. Often such work is done with the support of dies.

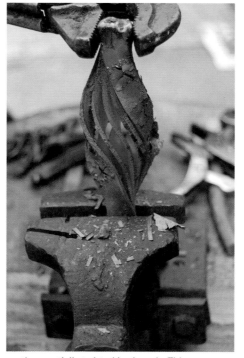

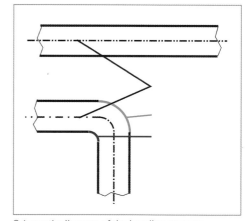

Five flat 0.8-by-0.08-inch (20 × 2 mm) bars, welded on the front sides. Preparation for the twisting process. First, the welded-together flat steel packet is twisted for half a twist and . . .

. . . then partially twisted back again. This opens up the flat steel packet, as shown in the picture. You can influence the size of the opening by vertical pressure.

Schematic diagram of the bending process

For compression, it is a good idea to heat the area as locally as possible and to work by using powerful blows.

We use various tools for bending circular elements and arcs. These include the anvil horn, anvil edges, the rounded and curved

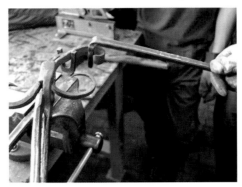

Bending a forged piece with two bending forks

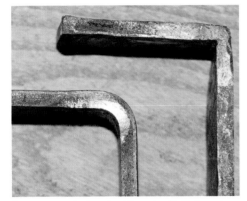

Bent rectangular bar: bent in a vise (*left*); forged afterward to a sharp edge (*right*)

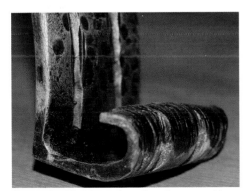

Sharp-edged bend on a foot piece, but created by welding

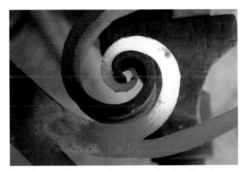

Bending a volute by using a bending jig (bending template)

stakes attached to the anvil, the circular part of a vise, stepped cylindrical disks, and bending templates.

When bending using bending forks, clamp one bending fork into the vise and guide the second bending fork by hand. The workpiece is bent in small steps, creating the smallest possible increments.

If you are making several similarly bent forged pieces, then it is worth your while to make a bending jig (bending template). This is bent out of flat steel with a larger cross section than the workpiece to be bent, by using bending forks. To stiffen it, sometimes sheet metal is welded to the underside of the jig. For bending work, it is a good idea if the inner part (beginning of the bend) is positioned higher than the end of the jig. This allows the workpiece to bear against the device better. In addition, it must be noted that the workpiece becomes larger than the template, since it is placed on the outer side of the template.

Pipes of different diameters also work well for making bent workpieces. You can use locking pliers to fix the workpiece to the upper end of the pipe. The loops are then twisted downward. You can fashion circular

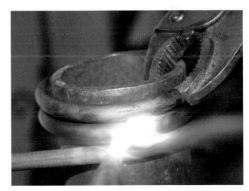

Bending rings of round steel over a pipe. Here the round steel is heated with a gas burner.

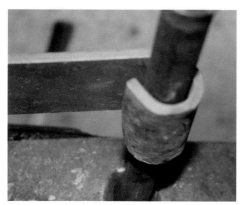

Bending a door hinge over a round mandrel, set in the anvil's square hardy hole

arcs by bending over a mandrel. The mandrel can be inserted into the anvil hardy hole and provides a stable hold due to the weight of the anvil.

Joining

There are several possible processes to join forged pieces:

• riveting
• screwing
• soldering
• welding
• making a collar

Which process you use depends on various factors, such as which stresses the workpiece is exposed to, or which visual impression you desire. But the technical possibilities for making the workpiece also have a major influence on selecting the process.

Riveting

Riveting is a joining method that has been used for centuries and has lost its importance only due to the development of modern welding technologies. Compared to welding, it has the advantage that it causes no stress or warping to the workpiece that could impair its mechanical properties and, if necessary, require heat treatment. A further advantage of rivet joints is that this method can be used to join different materials together. Classic examples of the application of riveting were riveted steam boilers and, with the advent of metal ships, the dense riveting of the ship's plating. These rivets were struck when red hot, and the thermal contraction during the cooling brought intense surface pressure to bear, which created the seal. While stability and seal tightness were decisive in these applications, for articles of daily use, creating a pleasing form is the main focus. The rivets used for this purpose usually have a diameter of less than 0.4 inches (10 mm) and can therefore be shaped when cold. Often, the visible rivet head is designed as an ornamental head, using hardened inserts.

A right-angled bent sheet is riveted to a bookend. On the inside, the rivet must be flush with the metal sheet. For thicker parts, the hole is recessed on the countersunk head. Since here the sheet is too thin to sink the hole, recess the hole in the thicker component, and the sheet is pressed in.

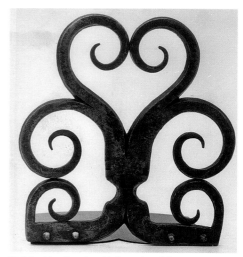

Finished bookends with four rivet joints

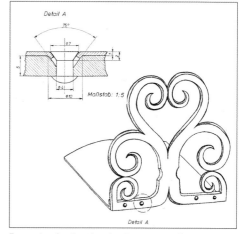

Example of using the riveting process for a bookend

Types of Rivets

For forging work, mainly full rivets with a countersunk head or round head are used. The rivet length must be greater than the total thickness of the parts to be joined; namely, 0.5 to 1.0 × rivet diameter for a countersunk head and about 1.5 × rivet diameter for a round head.

Holes are drilled in component 1 and component 2, according to the rivet, and the rivet is pushed through until it projects (excess length). Using the rivet setter, the two components are pressed together so there is no play. The rivet head is then shaped using a hand hammer. To create a beautiful head shape, you can also use a stamp with a semicircular shape or decorative form.

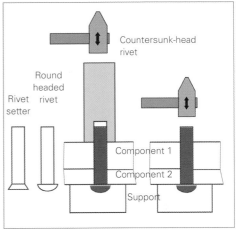

Schematic diagram of riveting two components

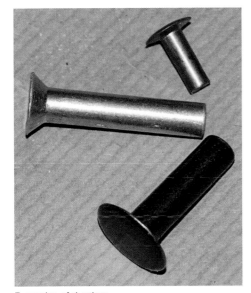

Examples of riveting:
Top: copper rivet with raised countersunk head
Center: rivet with countersunk head made of aluminum
Bottom: steel rivet with raised countersunk head

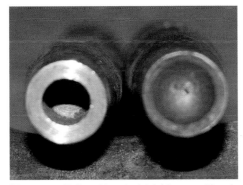

Rivet setter (*left*) and header (*right*) for round heads

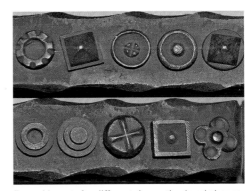

Forged inserts for different decorative head shapes

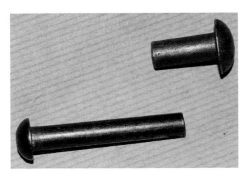

Steel roundheaded rivets

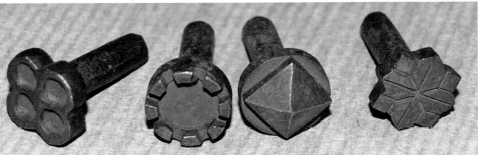

Examples of decorative shapes for rivet heads

Typical rivet joints using a round head are found on fences and railings.

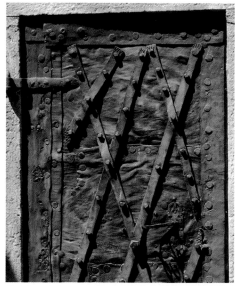

Old church door studded with forged sheet metal. The door was reinforced by riveted flat iron and protected against any break-ins.

Two rivets were used to rivet a hammered bar to a round arch by two rivets with ball head. The second side is designed as a sunken rivet.

Examples of Rivet Joints

Screwed Joint

Screwed joints are of secondary importance for forged pieces, especially for objects for daily use and decorative objects. Just as with riveting, it is possible to make screwed joints with ornamental heads and decorative screw nuts.

Soldered Joint

For this type of joining, we make a basic distinction between soldering and brazing. Soldering is done at relatively low temperatures (up to 842°F/450°C), and a solder of tin and lead is used. Soldering is rarely used in forging.

Brazing (soldering temperature above 450°C) is a common method for joining forged parts. Brass solder and silver solder (lower melting point than brass solder) in wire form are used as solders. The disadvantage is that the solder at the soldering point differs in color from the forged piece, so, if necessary, the soldering point must be painted. Brazing joints are a good alternative to welding; however, working with a welding torch is recommended, since it is difficult to reach the required soldering temperature with a propane burner.

Brazing

The parts to be brazed must be cleaned completely so that they can be wetted by the solder. The parts are locally heated with the welding torch to a light-red heat, and the solder is added to the flame.

The soldering wire in the form of a bar has, in most cases, a sheathing of welding flux that reinforces the wetting of the soldering joint. There is also brazed wire without flux sheathing. For this type, the flux is added as a powder. In this case, the solder wire is heated and immersed in the flux. In this process, the flux adheres to the hot soldering wire, and the situation is similar to that of coated soldering bars.

If the parts to be soldered are insufficiently heated or not well cleaned, then the solder does not flow and small balls form, which do not create any bond with the parts to be soldered. When the soldering is done correctly, the molten solder is drawn into the joining point by capillary action. After cooling, the rest of the flux remains attached to the soldering joint and can be easily removed with a wire brush.

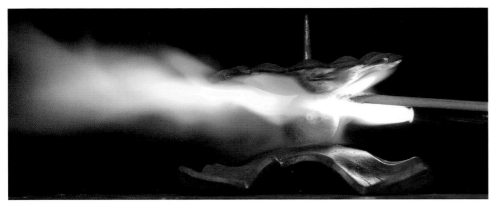

Left: Joining the individual parts of a small candleholder by brazing. The brazing bar is sheathed with flux (purple). *Right*: Finished solder joint.

In this case, the braze filler bar is sheathed with flux. The flux illuminates strongly during the melting process by the oxyfuel gas flame. Make sure that the parts to be joined are heated evenly.

After the solder joint cools, it is easy to recognize due to the brass color. This can be considered disturbing if it is at any visible place, but makes it easier to check the solder joint, since it is easy to see whether the solder flowed properly. A coat of paint—either locally or over the entire forged piece—ensures that nothing can be seen of the solder joint. When soldering is done properly, the solder is drawn into the soldering gaps by capillary action, and there is no notable application of material, as is the case with welding. Compared to welded joints, there is no significant warping.

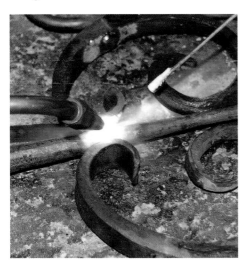

Joining the individual parts of a candleholder by brazing. The parts to be joined are first positioned exactly and then heated to brazing temperature with the oxyfuel gas flame. When the required temperature has been reached, add the solder. Here, brass solder without sheathing was used. The brass bar is heated and immersed in the powdered flux, which adheres to the heated places (*picture left*).

Soldering

Soldering is rarely used in forging. Sometimes forged pieces are enlarged using copper plate elements. In this case, the soft soldering method can be used.

The temperature of a propane gas flame is sufficient to heat the pieces to be joined. It should be noted, however, that copper is an exceptionally good heat transfer agent.

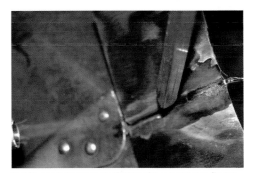

Soldering two copper plates with a propane flame (*left*). The soldering bar can be seen in the middle of the solder joint.

As a result, it is hard just to heat a localized area. As for all soldering processes, a blank solder joint is required to ensure the wetting of the solder. After thorough cleaning with a wire brush and possibly with sandpaper, to solder the workpiece, apply a liquid flux. When it is brought to the required soldering temperature, the solder is added.

Welding

Welding is the joining of two similar types of materials. In most cases, forging involves welding pieces of steel.

Forge welding developed historically in the field of forging techniques. It no longer has any economic significance. Autogenous welding is also used occasionally, since there is usually autogenous equipment in forging workshops. Modern production processes are familiar with a variety of welding processes that meet the highest requirements.

Forge Welding

In the following section we will deal with forge welding.

For a long time, forge welding was the only method of combining two similar types of materials. This made it possible to join different qualities of steel together. The method was used to give tools that require a hard cutting edge (axes, knives) a soft-base body and a cutting edge that could be hardened. To manufacture Damascus steel,

soft and hard pieces are also welded together and then treated further.

In this joining process, you can exploit the fact that combining iron and carbon (= steel) has a melting range (compare, in the iron-carbon diagram, the area between liquidus and solidus line) in which the steel is in a doughlike state. If the two parts to be joined are heated till they reach this condition, they can then be welded by being pressed together—by means of hammer blows. An indication that welding temperature has been reached is when sparks start to spray out from the welding point. If it is heated too high, the workpiece can burn. It is also important to heat evenly over the entire welding cross section. In this process there is the danger that scale or impurities from the forge fire may be introduced into the welded joint.

For this reason, it is a good idea to forge the pieces together before starting the fire

Forge-welding a workpiece on the anvil

Forge-welded flat steels with different steel qualities. When they are heated, the various qualities of steel become different colors. This form of welding is applied when making Damascus steels.

welding. A method is also described in the literature where the parts to be joined are riveted together in a makeshift way to position them as precisely as possible. The rivets are then welded into the welding material during the welding process. Steels with a carbon content below 0.3 percent can be fire-welded well. However, these steels cannot be hardened. To weld low-carbon steels to hardenable steels, fluxes (such as borax) are strewn over the site to be welded. This absorbs impurities and forms a protective layer on the surface of the welding point that protects the weld from burning and scaling.

Gas Welding (Autogenous Welding)

Autogenous welding can be used for welding work on a small scale. This equipment can also be used for warming, soldering, and flame cutting. The gas mixture used consists of acetylene (C_2H_2) and oxygen. When

acetylene is combusted with oxygen, this produces the hottest flame of any combustion gas, at 5,612°F (3,100°C). Combustion with air yields a flame temperature of 4,172°F (2,300°C). It is necessary to comply with local safety regulations when working with acetylene and oxygen; otherwise there is a significant risk of an accident. The working pressures, depending on the thickness of the materials to be welded, are 0.2 to 0.8 bar for acetylene and 1.8 to 2.5 bar for oxygen. Special burners are also available for heating workpieces.

The disadvantage of gas welding is mainly the necessity to heat large areas of the parts to be joined. This large-area and relatively long-lasting heating may cause structural changes. If, for example, cold-worked pipes are joined by gas welding, recrystallization can occur along the weld

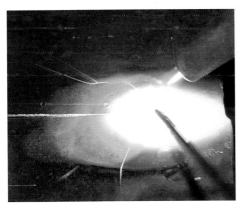
Gas welding (autogenous welding) of two pieces of sheet metal

seam, which makes it easier for a fracture to occur next to the weld seam. Gas welding has been demonstrated to be a convenient process for joining thin and small parts.

Arc Welding
The various methods for arc welding are state of the art. Therefore, they are sufficiently known to every metalworker, and I do not deal with them in any greater detail.

Making a Collar
Making a collar is a convenient joining method used in forging. For this process, the parts to be joined are collared, as with an enclosing clamp. Due to the cooling of the clamp, the steel contracts (thermal contraction), whereby the parts to be collared are firmly pressed against one another. It is also possible to use collars for cold working, but here no pressing effect is created by a cooling process.

In the simplest case, flat steel is used as the material for the collar, but we also use flat materials rounded on one side, or materials with beading.

To make collars, it works well to use simple devices in which the collar is preformed and closed after the parts to be joined are inserted. This also has the advantage that you can work quickly, since a collar cools rapidly because of its low mass. The two ends of the collar can be

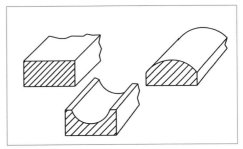
Examples of collar cross sections

made straight or pointed. In the latter case, the joint looks like a mounting. It is often difficult and complicated to hold the parts to be joined together while making the collar. In this case, you can fasten the parts by using a welded joint and then simply attach the collar. This then primarily has a design function.

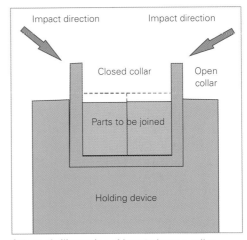
Schematic illustration of how to forge a collar

Example of joints made by rivet and collar

Collars are often used to make joints for church gratings.

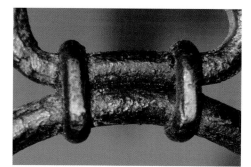

Two scrolls joined by two collars

Crimping

Two intersecting bars can be made to join at the same plane by crimping one rod. The two bars can also be riveted at the crimping point. An alternative would be to cut a bar at the crossing point and to weld the two bars together. Crimping is done at forging temperature. You can make a suitable tool for crimping a bar yourself. It is a good idea to make the crimping tool Examples of Crimping just slightly larger than absolutely necessary. This makes sharper angles on the crimped section.

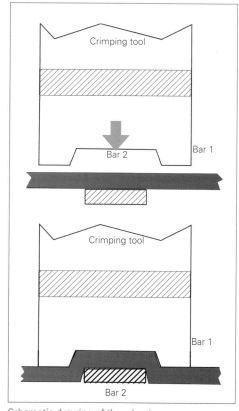

Schematic drawing of the crimping process

You can still rivet the crossed bars together to improve stability. If you do this, for visual reasons you should design the visible rivet heads as decoratively as possible.

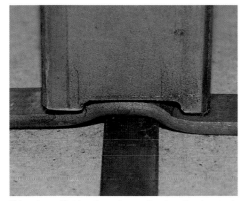

Crimping a flat bar by using a simple crimping tool

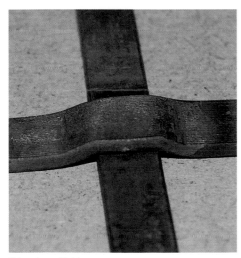

Crimping a flat bar

Crimped, riveted decorative bars for a grating. Various ornamental rivet shapes were used.

Punched Joints

This type of joining is a preferred method to make gratings.

There are no restrictions on the bar cross sections for punching. The bars can cross each other at arbitrary angles, with a right angle preferred. It takes a lot of effort to make a grating by this method. Weld or rivet joints are much easier and cheaper to manufacture. These manufacturing processes are used in steel construction.

A square bar can be punched in the following work steps: punch-marking the middle of the hole and then splitting the bar along a length corresponding to the diagonal of the square bar; this prevents reducing the cross section of the two sides. The slit area is therefore only curved up. The slot is made wider with a drift punch that corresponds to the cross section of the drift punch to be inserted. The drift punch should be tapered at its end so that it goes through by itself at the end of the opening.

After the slot is enlarged with a drift, it then must be aligned. Above all, the exterior

Simple window cross with punched bar in an old farmhouse in the Austrian Freilicht (Open Air) museum, Stübing, Styria

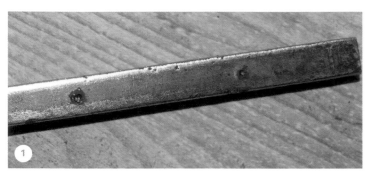

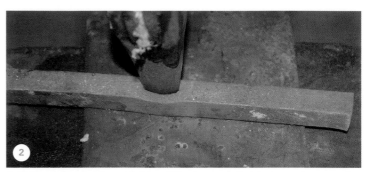

1. Square bar for punching. The middle points for the punching tool (splitting chisel or splitting hammer) should be forcibly punch-marked, so that they can be easily recognized even when the piece is red hot.

2. Slitting the square bar with the splitting hammer. A plate support protects the splitting hammer and the anvil face.

3. Enlarging the slot with a mandrel on top of a support with a hole

4. Finished bar with enlarged slot

Tools for enlarging a hole

Examples of punched joints

Complex joints for a candleholder

Church window grating with punched bars

surfaces must be designed to correspond to the punched interior surfaces.

Cutting

As is the case for most forging work, there are also many ways to do this task. Which one you select often depends on how your workshop is equipped and your preferred working technique. The possibilities range from the traditional technique of chiseling to computerized plasma- and laser-cutting methods.

Chiseling Off

This is the traditional method used for centuries to cut off workpieces when they are red hot. Chiseling tools are wedge shaped.

The necessary tools are a spalling hammer, sledgehammer, and chisel stake, the last of which is used on the anvil in the

Chiseling off a round bar on the anvil

square handy hole. Spalling hammers have narrow cutting edges and a wedge angle of 20 to 30 degrees. Mark the place on the workpiece where the cut is to be made with a notch before heating it. Set the red-hot workpiece in the marked position on the chisel stake and apply the spalling hammer on the opposite side. The workpiece is split by blows of the sledgehammer (by the blacksmith's helper or "striker"). If you have a thicker workpiece, it is a good idea to keep rotating the workpiece between the blows. It is necessary to cool the cutting surfaces of the spalling tools in cold water to prevent them from losing their hardness. This working technique does not create a smooth cut surface.

Splitting

A workpiece is split in a way similar to chiseling it off.

Splitting is a frequently applied work technique in artistic forging. The split areas must be reforged, since the splitting process does not create clean surfaces. It is also difficult to guide the splitting hammer exactly in the center. The splitting process is done on the anvil, and it is necessary to put a nonhardened support, such as sheet metal, between the workpiece and the anvil. Protect the spalling hammer from overheating by cooling it in cold water. Hot-working steel, such as material no. 1.2343 (X38QMoV5-1), is a good material for the spalling hammer.

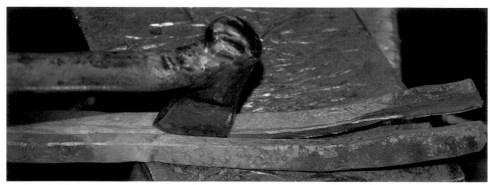

Splitting a flat bar. The spalling hammer shown in the figure has a sloping handle so that your hand is not positioned exactly above the red-hot workpiece.

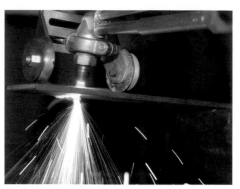

Oxyfuel cutting a flat piece of steel

Bench Shears

Almost every steel-working workshop is equipped with bench or slitting shears. These are designed mainly for cutting sheet metal and bars in the cold state but are also occasionally used for making short separating cuts in red-hot workpieces.

Abrasive Cutting Machine

Single- or two-hand angle grinders are often used for making separating cuts. By using

only 1 mm thick cutting disks for single-angle grinders, it is also possible to use this machine for splitting.

Cutting stands have shown their worth for angle grinders, which make it possible to clamp the workpiece and make straight cuts.

Oxyfuel Cutting

Oxyfuel cutting is used mainly on thicker workpieces. Depending on the thickness of the workpiece to be cut, there are corresponding burner inserts for the cutting torch. In principle, when you start to cut, heat the cutting torch to red hot, and then, by increasing the oxygen content of the flame, the steel near the flame is burnt. As a rule, it is necessary to rework the cutting joint.

Plasma Cutting

This is a combination of gas and an electric arc. The plasma is an electrically conductive gas with a temperature of 54,032°F (30,000°C). With this method, it is possible to obtain smaller parting lines and nicer cutting surfaces than when using oxyfuel cutting. The torch guidance is generally computerized. Plasma- or laser-cutting systems are available from many machine-engineering companies. It is often a good

Bench shears

Cutting stand for a single-handed angle grinder

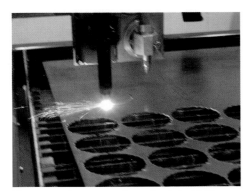

Plasmas cutting rosettes from sheet steel (Höhere Technische Bundeslehranstalt Kapfenberg)

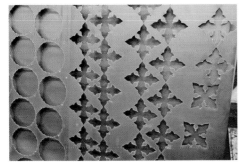

Workpieces cut out of a metal sheet for a candleholder. Computerization produces perfectly identical workpieces.

idea to have the sheet-metal parts needed for the forging work cut out in an appropriate workshop.

Fullering

Fullering reduces the cross section at one point to create a step. The displaced volume goes into the length and width of the stepped workpiece. For fullering, mark the section to be fullered with a groove. Fullering is done with a blacksmith's fuller hammer and sledgehammer.

If you have two crossing bars, it may be necessary to fuller at the crossing point if the two bars are to lie in one plane.

Both bars are fullered up to half the workpiece thickness. At the same time, you have to decide where the displaced material should go. Usually, you maintain the workpiece width, and the displaced material makes the bar longer.

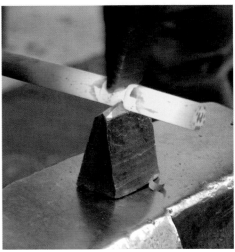

Making a groove in the area to be fullered at the end of the workpiece

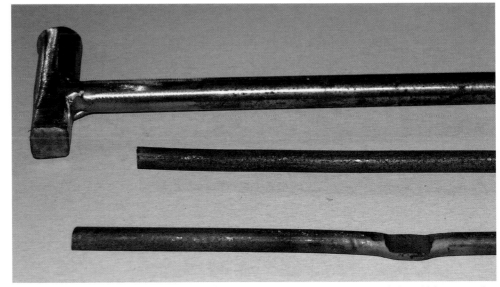

Fullering between the ends of the workpiece. *Top*: Fuller hammer adapted to the workpiece thickness, made of tool steel. *Middle*: Undeformed bar. *Bottom*: Fullered bar.

If you decide to set up a forging workshop, it is imperative that you comply with all external conditions. It is impossible to prevent noise and smells from penetrating the outside world.

The pieces of equipment described in this chapter are necessary for the basic equipment of a forging workshop.

Over the course of the millennia since forging has existed, we have continued to develop the basic materials and the equipment and tools necessary for forging.

While the changes in handicraft workshops are not as serious as those in mechanical manufacturing, industrial forging has undergone its own development, particularly with respect to features of quality such as repeat accuracy, dimensional accuracy, the size of the workpieces, and mass production.

Essentially, heating facilities, anvils, hammers, tongs, or handling tools are required both in the small forging industry and in industrial operations.

Many tools and devices adapted to specific work are made in the forging workshops themselves. This is particularly true for hammers, tongs, and small devices.

The industrial sector is not dealt with in any more detail here.

Heating Facilities

Heating facilities, also known as forges, are probably the most important elements for forging. They also give the appearance of a smithy its special character: fire, heat, soot, and the typical scent of a coal-fired forge. For many hobby blacksmiths, it is a problem to find a suitable heating facility for their workpieces and to install it without disturbing their neighbors. Whatever method you choose to heat your workpieces depends primarily on what you require. Manufacturing plants with serial production primarily require cost-effective solutions. This is especially true for fuel costs. Constant uniform heating of the forged pieces is another absolute requirement. In this case, gas- or oil-fired industrial furnaces are generally used.

For a forge that is in operation only occasionally, we usually look for solutions that fit into the overall concept of the workshop. For small workpieces, an autogenous welding system is often sufficient to heat the workpieces. If you are doing forging work on a permanent basis, a coal- or coke-fired forge is the standard.

Old blacksmith's workshop with coal-fired forge. In the foreground is master smith *Fachoberlehrer* [specialist head teacher] Johann Loidolt, one of the author's forging teachers. These characteristic heating facilities include the central fire pot with annular air inlet and slag chamber, the large smoke exhaust, the bellows with a lever to regulate the air flow, water tank (*left*) for cooling the forged pieces, and a large number of tongs and hammers within arm's reach. There is more forge coal next to the hearth, which can be added to the fire as necessary.

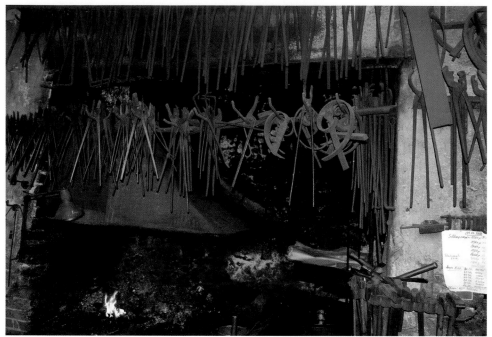

Typical hearth in an old smithy. Tongs, bending jigs, and simple dies are arranged right around the workplace.

Coke has a much higher ignition temperature than forge coal or charcoal.

Forge coal produces high combustion temperatures, cakes well, and is relatively heavy, and therefore its position won't be changed by the air from the bellows. A disadvantage is its content of sulfur and other undesirable components that can adversely affect the quality of the forged material. Steel with a too-high sulfur content is red-brittle, which means that when a bar is bent at forging temperature, cracking may occur. Coke contains almost no sulfur, which escapes during the coking process; it produces a red-hot fire with a low flame, and as a result it is easier to see the workpiece than if you are using forge coal. Wood charcoal is light, free of sulfur, and burns rapidly but will not produce a high temperature and is uneconomical for commercial work. When using forge coal, some measures are recommended. It is important to create a "bed of embers" covered by a small amount of burned coal, which shapes a crust over the embers. Moistening the outer layer of coal makes it cake together. You can use a metal pot with a handle and small holes in the bottom to dampen the coal. When the flame starts burning yellow, this is an indication that the sulfur in the coal is burning. It also proves to be a good idea to build up the coal at the edge of the fire, so that the volatile matter in the coal can escape. Slag forms in the fire

The most-common heating facilities used in forging are described in the following sections.

Coal-Fired Forge

For thousands of years, this has been the classic smithy fire and is still in use today. The usual fuel for coal-fired heating devices is forge coal (crushed hard coal) or forge coke. Wood charcoal is occasionally used. Forge coal is sifted and washed and is available mostly in size nut IV, which means that the size of the coal pieces is 0.4–0.8 inches or 10–20 mm (nut III = 0.8–1.2 inches [20–30 mm], nut II = 1.2–2.0 inches [30–50 mm], nut I = 1.6–3.3 inches [40–80 mm]).

The term "fat coal" refers to the carbon content (about 88 percent) and the volatile matter content. Fat coal is also used for the production of coke. Forge coal should not contain much sulfur, since this can penetrate steel during the heating process and can adversely affect its quality. Coke contains little sulfur, and charcoal contains no sulfur.

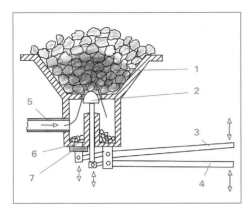

Basic design for a firebox made of cast iron. Forge fire (1), control valve for the amount of air from the bellows (2), manual operation by hand lever (4), hand lever (3) for operating the slag discharge valve (7), tube for the bellows air feed (5), opening (schematic) for emptying the slag and coal pieces that fall through the air channel (6)

over time, in clumps or in a ring around the bellows nozzle, and should be removed using slag hooks.

To create a sufficiently high temperature, it is necessary to feed the fire with additional combustion air from the bellows. This increases the speed of combustion and thus also the temperature of the forge fire. The airflow must be adjustable (for example, by restricting the cross section in the supply line to the firebox), in order to adjust the size of the ember bed to the size of the workpiece. When the forge is "idling" and you are working on the workpiece, the bellows should be operated with minimal power to save fuel.

Gas Forge

Gas forges develop almost no smoke. Combustion of natural gas or propane produces only carbon dioxide and water, as long as the gas is not contaminated (such as with sulfur). The exhaust gases are colorless. Gas forges likewise use a firebox. Instead of the coal, ceramic chips are put in the firebox and are heated by the gas flame. The workpieces are heated indirectly by the red-hot ceramic chips.

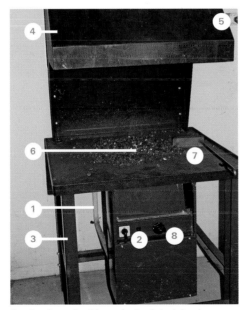

A natural-gas-fired forge for basic training in forging (Höhere Technische Bundeslehranstalt Kapfenberg, Austria). Gas supply (1), main switch (2), frame (3), gas exhaust hood (4), emergency stop switch (5), ceramic chips on the gas flame generate a bed of embers (6), a hand tool to distribute the ceramic chips (7), switch for setting the size of the gas flame (8).

Gas-powered forging furnace for making forged pieces by machine

Mobile Gas Forge

These forges are heated with propane gas and are suitable for heating small workpieces. They are used mainly by farriers who have packed all their forging tools into a vehicle.

The combustion chamber can be closed with a door. As a result, the heat loss is low and the propane gas flame is enough to reach forging temperature.

Field Forging (Mobile Forging)

Field forging means a mobile forging workshop. Mobile forges are often popularly referred to as field forges. They are the preferred forges used in forging demonstrations. In the essentials, the design is similar to that of a stationary forge.

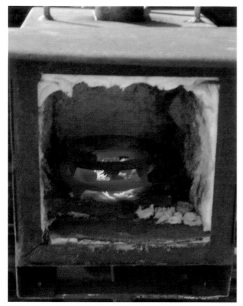

A farrier's propane-heated mobile forge. The sheet-metal housing for the hearth is lined with fireproof insulation mats. The gas burner is attached through an opening in the back.

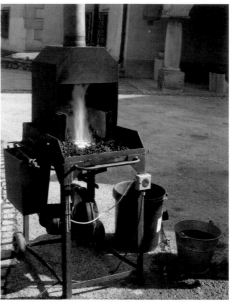

This mobile field forge has a coal fire with bellows, water containers, and additional holders for fire tongs and hammers.

Oxyfuel tools work well for heating small workpieces. They are also used for brazing and gas welding. Blacksmiths occasionally use oxyfuel tools for flame cutting.

Propane Gas Jet

Propane gas jets do not reach the temperature of an oxyfuel flame and do not work well for heating forged pieces to forging temperature. They are better suited for soldering and also brazing small workpieces. Propane gas jets can likewise be used for blackening or for tempering workpieces after hardening.

Hammer and Anvil

Next to the smithy fire, the hammer and anvil are the characteristic elements of the blacksmith's occupation.

Oxyfuel Tools

A flame of acetylene gas and oxygen gives valuable service for doing many small jobs. Above all, it makes it easier to localize the heating process than a forge fire does. Forty-liter cylinders are generally used for commercial work, but smaller cylinders are also available. You can rent or buy the cylinders. It is necessary to get a safety inspection for the cylinders, which significantly increases the cost of oxyfuel tools.

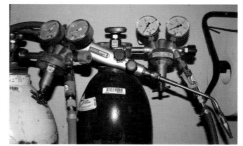

Oxyfuel unit consisting of oxygen cylinder, acetylene gas bottle with valves, check valve, and burner

Blackening with a propane burner. Coat the forged piece with linseed oil and burn off the oil with the propane burner. The combustion residue creates a nice surface.

Anvil

Anvils are cast or forged from cast steel. The anvil face is hardened.

There are many different designs, adapted to which forged pieces are being made or to the blacksmith's personal concept of forging. The anvil's weight is a significant dimension; this must correspond to the size of the workpieces the blacksmith is making. For setting up an anvil, it is important to have a stable foundation, such as a hardwood block or a metal-cased concrete block. The anvil must be able to absorb the impact energy from the forging hammer. If the hammer strikes the anvil, it creates a bright sound. If the anvil does not weigh enough, it can spring or vibrate, creating a bad effect on the forging process.

An anvil's characteristic elements are its solid design, its conical horn on one end, and its rectangular heel on the opposite end.

The main work surface is the anvil face, which is hardened. The anvil face drops off at a right angle on one side; on the other side it is slanted. This is useful for forging the point of a workpiece.

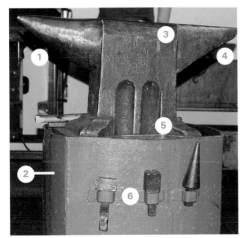

Typical anvil: horn (*1*), anvil support with elliptical arches, concrete with steel coat (*2*), anvil face (*3*), slanted side of the anvil (rectangular anvil horn) with sharp edges for bending work, with square hardy hole for additional tools (*4*), recesses for upsetting work (*5*), holders for tools that you insert in the square hardy hole in the anvil (*6*)

Hammers

We must make a basic distinction between hand hammers and power hammers. The following list shows one possible way to classify them.

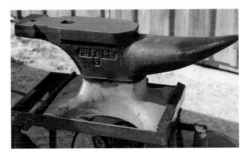

Anvil for a field forge. The striking features of this anvil are the long pointed horn and the offset anvil face.

Small anvil with elongated pointed design on a metal base

Classification of Forging Hammers
- Hand hammers
 - flatter hammers
 - roundheaded hammers
- Sledgehammers
 - blacksmith's sledgehammers
- Anvil top tools
 - spalling hammer
 - blacksmith's fuller hammers
 - drift hammers

The edge of a splitting hammer is rounded, so therefore it is easier to guide the hammer straight than if the edge were straight. So that you can use a splitting hammer as a tool to drift a hole in the workpiece, the hammer is shaped so it runs into the required contour (rectangular, flat, circular, and elliptical cross section) gradually.

The peen of a cross-peen hammer runs in the direction of the hammer handle and therefore works well for spreading a the peen is perpendicular to the hammer handle and works well for stretching. These hammers weigh 11–33 lbs. (5–15 kg) and are used as strikers with anvil top tools, such as splitting hammers, fuller hammers, finishing hammers, and so on. For the anvil top tools, the handle should sit loosely in the hammer, to compensate for any bounce that might be caused by the blows from the sledgehammer.

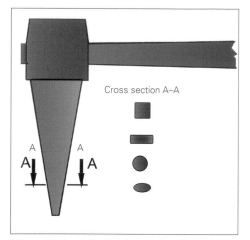

Schematic sketch for the design of a splitting hammer

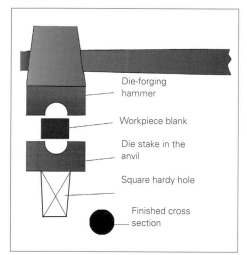

Schematic sketch of a round die with anvil stake and die-forging hammer

Cross section A–A

A

A

Die-forging hammer

Workpiece blank

Die stake in the anvil

Square hardy hole

Finished cross section

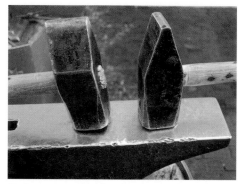

Sledgehammer (*right*) and cross-peen hammer (*left*)

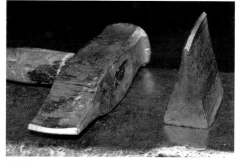

Splitting hammer and chiseling stake on the anvil

Power Hammers

The striking energy a person can generate by hand is relatively limited. It used to take many hours of hard work to manufacture a scythe by hand alone. The invention of powerful, waterpowered hammers set off a revolution in blacksmith work. This made it possible to make larger workpieces with a lower expenditure by the workers.

Due to this invention, forges with water-driven hammers and grinding stones were built on many streams and rivers. Mills and sawmills also used hydropower.

The electrification of our country brought a further change. Gradually, water-driven power units were replaced by electric power units. Electric-motor-driven spring hammers were introduced in forges, facilitating a blacksmith's work considerably.

Besides spring hammers, pneumatic hammers are also used.

Bench Vise

Blacksmith's vises, known in German as "bottle vises," are used mainly in forge workshops. Since the movable jaw is guided by a fixed pivot point, the jaws are not

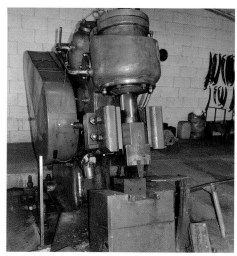

Compressed-air-operated power hammer in a scythe forge

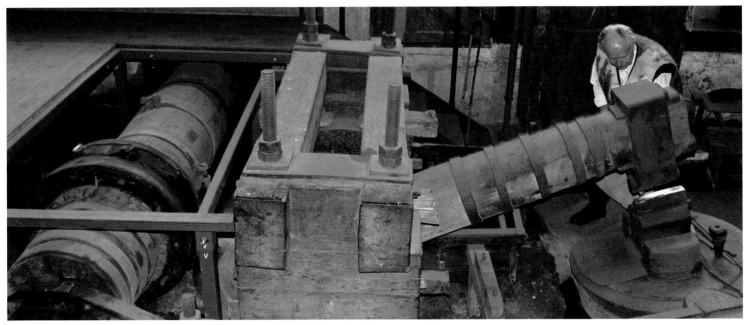

Waterpowered tilt hammer in the Schmiedemuseum Deutschfeistritz, Styria, Austria

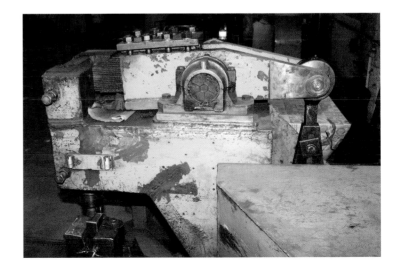

Spring hammer in a forging plant. *Left*: hammer and spring pack; *middle*: pivot (bearing); *right*: crank drive. The spring hammer has been designed to make a short stroke and a high number of strokes (thick, short spring pack).

parallel to each other when the vise is open. This often works negatively compared to a parallel vise. However, the two jaws are forged or cast from steel, so that a blacksmith's vise is completely impervious to any blows. The movable jaw is not fastened tight to the movement spindle, so it can be moved by hand on the fixed jaw. A spring ensures that the movable jaw always lies against the spindle. The jaws have roundings and edges that can be used for bending work.

Tongs and Pliers

There are plenty of tongs and pliers of different shapes and sizes at hand in every forge. Often the blacksmith makes the tongs himself.

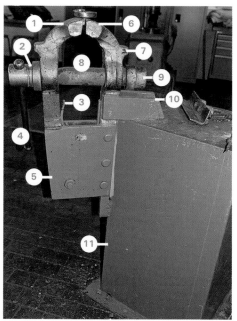

Blacksmith's vise mounted on a heavy metal housing. These vises are also often mounted on the workbench. They must be fastened firmly because the vise has to withstand a great deal of heavy work and shock stress. Movable jaw (1), spindle (2), spring that presses the movable jaw away from the fixed jaw (3), toggle (4), pivot for the movable jaw (5), fixed jaw (6), horn for forging work (7), protective sleeve for the movement spindle (8), nonrotating nut for the movement spindle (9), vise fastening (10), heavy metal housing (11).

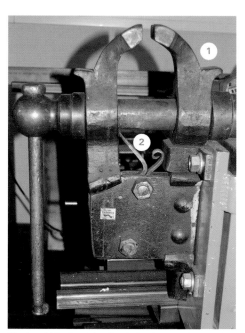

Blacksmith's vise—the fixed vise jaw can be used for bending (1). You can see the back pressure spring (2) for the movable jaw clearly on this vise.

Extremely large blacksmith's vise on the Sachan company premises, St. Lorenzen in the Mürztal, Styria

The parts of a pair of tongs include the jaw, which holds the workpiece, the rivet as a pivot, and the reins, which you hold by hand. The ratio of the jaw length to rein length should be about 1:6, to give the tongs enough clamping force on the workpiece. At this ratio, the jaw produces roughly six times the hand force. The shape of the jaw should be adapted to the workpiece. The tong reins are frequently equipped with locking devices to relieve pressure on the smith's working hand during forging.

There are a variety of different tongs for forging. Since the tongs usually come into contact with the forging fire, they are also referred to as fire tongs. A smith often forges his own tongs and adjusts them to his forging needs. There are various methods for locking the tongs.

Locking Pliers

These pliers are also known under the name of grip pliers. You can adjust the width of the opening with a screw. The pliers have a toggle lever mechanism, which makes it possible to generate heavy force at the jaw. These work well for twisting, welding, and soldering.

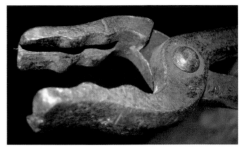
Design of the jaws of fire tongs

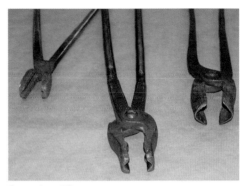
Examples of fire tongs

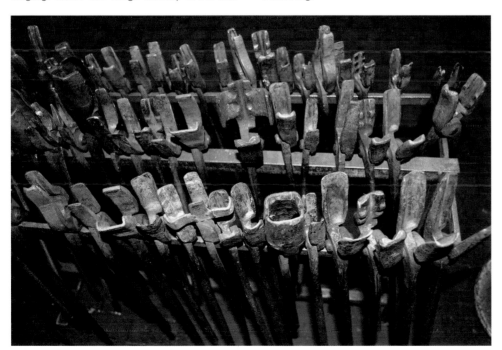
All kinds of shapes and designs for fire tongs

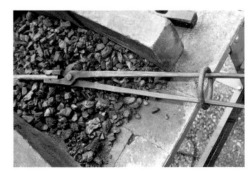
Locking device for fire tongs using a ring. The tongs' long, slender reins generate a good spring action, which ensures a good hold on the workpiece in the tong jaws.

Auxiliary Equipment

If you are working without a helper, you will need to fasten the red-hot forged piece you are working on to the anvil. You can do this with a self-made spring or with a weight-loaded chain.

Swage Block and Die Plate

This tool has a variety of bores and holes for upsetting and embossing work. On the sides there are various indentations of different radii for shaping and rounding.

Fire Tools

The blacksmith needs some tools to keep the forge fire going in a coal-fired forge.

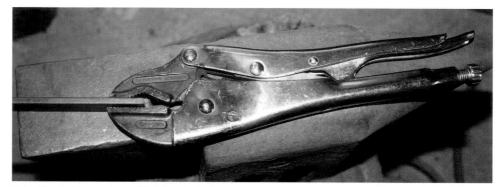

Grip pliers holding a piece of flat steel in the jaws

Holding the workpiece by using a prestressed hook in the hardy hole

Spring holding clamp on an anvil

Fastening the workpiece using a weight-loaded chain. Motorcycle drive chains work particularly well; they are fastened on one side of the anvil and are loaded with a weight on the other side.

These include a coal shovel, poker, fire pike, and water container with holes for moistening the coal.

Hydraulic Press

Hydraulic presses are a practical addition to the workshop equipment. In most cases, a manual press is enough. You can sometimes use such a press instead of striking with a sledgehammer.

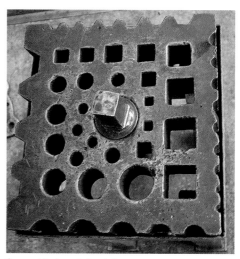

Swage block and die plate

Twisting Wrench

Twisting tools with a square hole come into frequent use in forging workshops. These have the advantage over a twisting iron with an adjustable jaw in that they can absorb a larger amount of force.

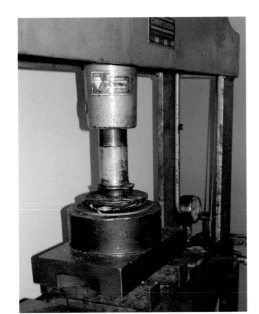

Hydraulic press for making a drip catcher for a candleholder. The circular sheet is pressed into a spherical shape by using a spherical punch. The press is operated by a hand lever.

Shaping a bowl with a die and the help of a sledgehammer

Thickness Gauge

If you are fashioning red-hot workpieces, you cannot use a roll scale or a sliding caliper. Thickness gauges made of sheet metal are used in forge workshops to determine the thickness or a bar's diameter. These gauges are sufficiently accurate for most forging work.

Anvil Attachments (Anvil Stakes)

You can insert different attachments (also called stakes or stocks) in the anvil hardy hole. If these also have a square mount, they are twist-proof. The weight of the anvil provides a stable base. These attachments are used for chiseling off, and tapered attachments are used for bending radii or small dies.

Files

Files are occasionally needed for reworking workpieces. We distinguish between roughing and finishing files. As you would conclude frprimarily to remove material, while finishing files are used for fine finishing. We furthermore distinguish among flat files, round files, semicircular files, triangular files, square files, and knife files, according to their cross section. The size of the file you use depends on the size of the workpiece you are fashioning. Very small files are called needle files (*Schlüsselfeilen*

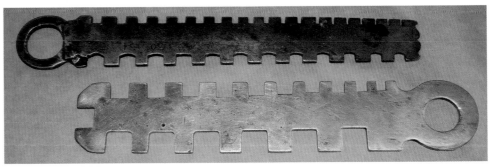

Thickness gauges for red-hot workpieces

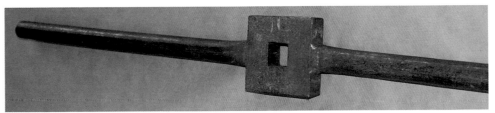

Twisting wrench with fixed square opening. As with most forging tools, this also has a robust design.

47

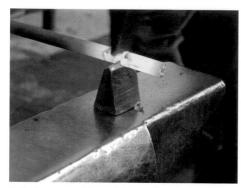

Fullering a round bar on the anvil

Simple die for die-forging a ball. One-half of the die is inserted in the anvil hardy hole.

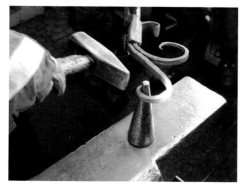

Conical stake in the anvil hardy hole

or key files in German), which work well for making keys.

As with all tools, there are also great differences in quality among files. You need high-quality files to work successfully on forged pieces.

Welding Tools

Welding work is done frequently in a blacksmith's shop. Fire welding, as the

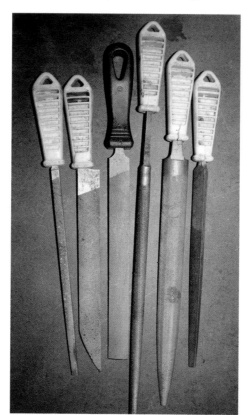

Roughing and finishing files; triangular, semicircular, round, flat, knife, and square

classical welding process of the smithy, has historical significance and is primarily shown in demonstrations. It is also possible to do small-scale welding work by using an oxyfuel tool. Otherwise, arc welding, either with jacketed electrodes or protective gas, is usual.

Tools for Grinding and Sanding

There are many ways to do grinding and sanding work, manually or mechanically. Use of a machine is often limited by the shape of the workpiece. The terms "grinding" and "sanding" are not clearly distinguished. Grinding is more associated with removing material, while sanding is, rather, enhancing the surface by a fine sanding, such as using an emery cloth or an emery disk of different grain sizes. Apart from stationary bench grinders, one- and two-hand angle grinders are in frequent use. Roughing disks are used for removing material, om the name, roughing files are used cutting disks for separating, and fan-shaped washers for fine finishing.

In addition to electric power, these machines are often powered by compressed-air drives. Compressed air is significantly more expensive compared to electric power but is safer against accidents.

Cutting stands provide good service for angle grinders; they allow you to make clean straight and angled separating cuts. These devices are available for one- and two-hand angle grinders.

Polishing Tools

For some forged pieces, such as forged knives, it is also necessary to polish them after grinding and sanding. The polishing process is time consuming and calls for a very well-finished surface since the polishing does not result in any significant material removal. You can mount a polishing wheel on the bench grinder for polishing with a polishing paste. You can also polish by hand

One-hand angle grinders for a disk diameter of 4.9 inches (125 mm). *Left*: abrasive cutting machine with 1 mm thick cutting disk. *Center*: rough grinding machine. *Right*: one-hand angle grinder with sanding disk (fan washer).

Bench grinder

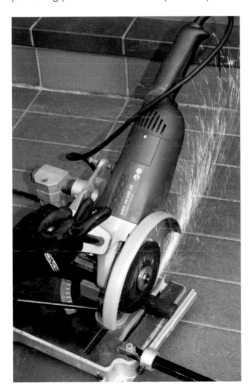

Cutting stands for angle grinders

with rags and polishing paste. It is not possible to remove large grooves by polishing.

Tools for Bending

Using a Vise

The jaws of a forging vise are rounded and can be used for bending work. The sides of the jaws are likewise rounded, and the heel on the fixed cheek is also suitable for doing bending work.

Bending Fork

Bending forks are always used in pairs. One bending fork is fixed; the other is guided by hand. The fixed bending fork is either clamped into the vise or inserted into the anvil hardy hole.

Bending Jig

Circular disks, arranged one above the other, work well for fashioning round disks.

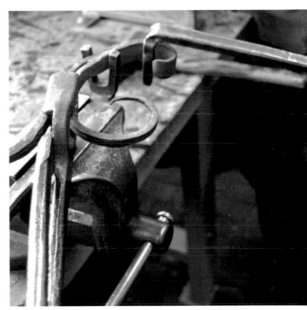

Bending scrolls with a bending fork. The fixed bending fork is clamped in the vise.

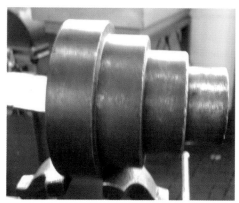

Device for bending circular elements

Bending Jig for Volutes and Scrolls

Bending jigs can be made for fashioning several identical bent parts. Care must be taken here that the part to be bent lies against the outside of the bending jig; thus it becomes larger than the jig itself.

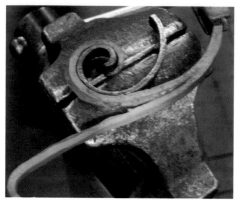

Bending a volute along a bending jig

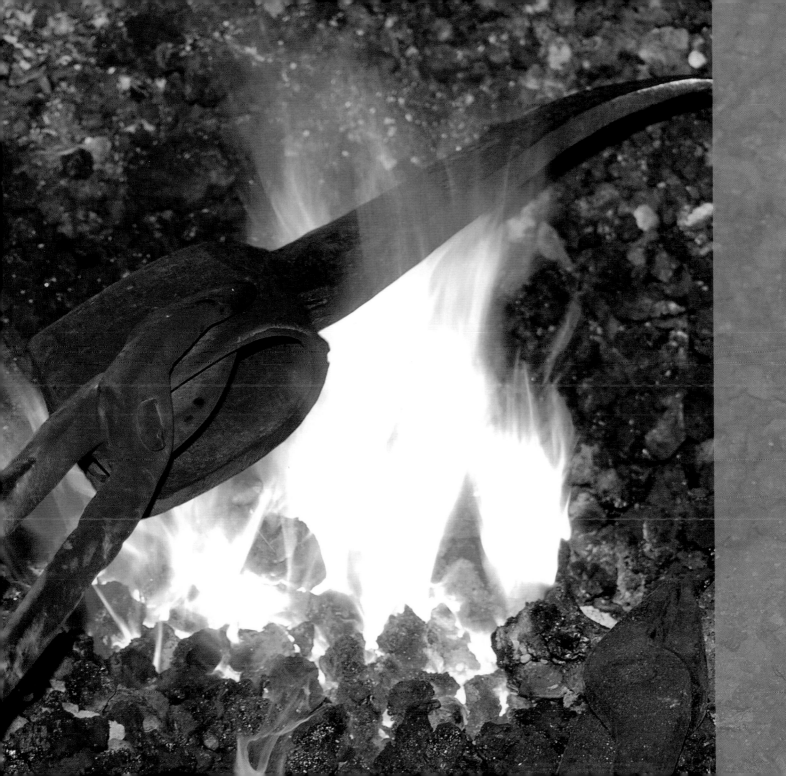

THE MATERIALS IRON & STEEL

Many of the known metals can be reshaped by forging. In quality and economic terms, steel is the most important.

A blacksmith's work is closely linked to the basic materials of iron and steel. In everyday language, terms such as iron, steel, cast iron, etc. are often not used correctly.

Therefore, in the following explanation we will deal, briefly and incompletely, with the most-common terms.

Ferrous Materials

We understand these materials to include all iron-based materials, from pure irons to highly alloyed steels, of which iron is the predominant component.

Pure Iron

Iron is a chemical element that is contained in the earth's mantle in small quantities (the earth's core consists of iron). Pure (solid) iron is rarely found on the earth's surface. As a rule, iron is extracted from iron ore with a maximum iron content of over 60 percent; iron ores are predominantly iron oxides. Pure iron melts at 2,797°F (1,536°C).

Iron can also be found in meteorites in a pure form (meteorite iron). This meteorite iron was the only available iron before the Iron Age began, and therefore was of great importance.

Pig Iron

Pig iron is the iron that comes out of the blast furnace. It hasn't been treated further (that is, it is still untreated). There is hardly any use for crude iron in this form. It can, however, be cast into ballast weights. Pig iron is processed further in the steel mill.

Steel

Steel is, according to its definition, an alloy of iron and carbon, with only small quantities (2.06% maximum) of carbon. In most cases there are other elements (wanted and unwanted) still present. In everyday language, steel is often referred to as iron. Steel is both hot- and cold-workable. As the carbon content increases, the melting temperature of the steel sinks and reaches its lowest value at 2,097°F (1,147°C), at a carbon content of 2.06 percent.

Cast Iron

Iron with a carbon content higher than 2.06 percent is cast iron. The carbon occurs in the form of graphite, which results in good sliding and damping properties. Cast iron cannot be forged and is only partially weldable. This iron-based material is brittle, and, in comparison to steel, we can influence its material properties only within narrow limits. However, the casting process makes it possible to manufacture complicated workpieces that cannot be made by forging. Sand molds are preferable for casting cast iron. Cast iron is neither hot- nor cold-workable.

Cast Steel

In this case, steel is cast in various alloys. Steel molds are preferred. In contrast to cast iron, we can cast alloys with specific properties, and therefore these are in direct competition with forged parts. Highly stressed steel parts can be produced by this process.

Wrought Iron

The term "wrought iron" is slightly misleading and goes back to steelmaking at the beginnings of industrialization.

This general definition, in common use since the early twentieth century, also includes low-carbon steel, which was hardly produced at that time but also had a carbon content of less than 2.06 percent, under the term "steel." The term "wrought iron" does not describe the components of the alloy and only partly has to do with its malleability. For many centuries, the "iron" extracted from ores has been freed of slag particles and impurities by forging, and its carbon content was affected by the frequent heatings. Processes were developed for manufacturing deformable iron parts, which were essentially based on different methods of refining iron bloom and subsequent forging. While wrought iron has the same carbon content as today's steel, it is not

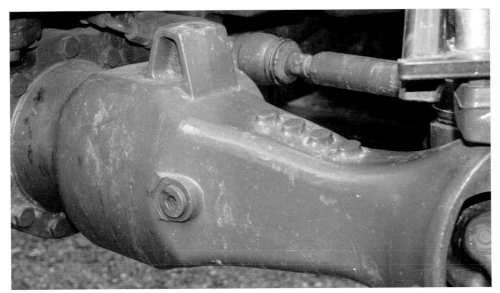

Example of cast iron: front axle of an agriculture tractor

Technical forged piece. Materials of the highest quality are required to make such forged pieces, to avoid any unforeseen failure of the forged piece. Processes have been developed in metallurgy that make it possible to produce such steels.

Forged chain link made of wrought iron. On the left side you can see an oblong slot, which is presumably due to embedded slag or a bad bonding process during the forging of the initial material. Material analysis by spectral analysis did not show any useful result because the steel in the chain link exhibited too many impurities, presumably in the form of slag from the steel production process

qualitatively identical to the steel currently being produced in the industrialized countries, due to contamination with other materials and incomplete removal of slag, which cannot be influenced.

Basic Materials for Forging

Many metals and alloys can be reshaped by forging. In terms of amounts, steel and the malleable alloys are the most important.

Alternative methods to forging are steel casting, cold forming (sheet metal), and chip removal (corrugating). These processes are often also used in combination.

Iron

Iron in its pure form has only limited use. It has a melting point of 2,797°F (1,536°C) and is magnetizable (ferromagnetic). The earliest findings indicate that we used meteorite iron (meteorite iron has a high nickel content) before humans learned to extract iron from ores. Iron is well suited for forging, but the availability of semifinished products is lower than that for commercial mass-produced steels. The mechanical properties of pure iron are poorer than those of steel. Due to its good magnetic properties, pure iron is primarily used in electrical engineering (such as lamination or electromagnets).

Iron and Steel Production

Iron is made from iron ore. This is extracted by mining, and the iron content differs

depending on the deposit. To ensure economical production, the ore should have an iron content of more than 25 percent.

Iron ore is converted into pig iron through a chemical process in the blast furnace. In this process, the oxygen (in the iron ore) that is bound to the iron in the iron ore is extracted and converted into carbon dioxide. The necessary energy and necessary carbon are generally provided by coke and natural gas. At the end of the blast furnace process, the pig iron is in liquid form. Its carbon content is too high and it contains unwanted metalloid elements, such as sulfur or phosphorus.

Pig iron is practically unusable. In the steelworks, such as in the LD converter (Linz-Donawitz method), unwanted iron elements are burnt by oxygen blowing, and the desired alloying constituents are admixed. This process is called refining. The extracted steel can then be cast into large blocks or fashioned into continuous square or rectangular cross sections in a continuous casting process. The blocks can be further processed by forging. In the rolling mill, continuous casting products are further processed into various cross sections such as bars, wires, sheets, etc.

Iron materials are fully recyclable. Therefore, steel production from scrap with or without the addition of pig iron is an important manufacturing process. Using electric furnaces is the preferred process for pure scrap processing without pig iron.

Steel

Steel is prominent among metal materials. We understand steel to be an iron-carbon compound with a maximum of 2.06 percent carbon. If the carbon content is higher, the result is cast iron, which is not forged.

By varying the carbon content and alloying with other materials, we can change the properties of steel, extending over a wide range (such as corrosion resistance, tensile strength, and toughness). By using a targeted heat treatment, it is possible to influence the steel properties further.

Steel can be alloyed with other metals to generate certain material properties. This also makes it possible to have a higher carbon content than 2.06 percent. For example, alloying with chromium to make the steel corrosion resistant limits how much the steel can be hardened, so the carbon content must be increased to obtain a high degree of hardness. Pure carbon steels without additional alloying elements can be hardened with a carbon content starting from 0.4 percent. By increasing the carbon content, it is possible to obtain high hardness values, which is an advantage for making cutting tools, but these steels are not rust resistant. The hardenable steels can be welded only under special conditions, such as preheating the workpiece.

Making stainless steel requires a chromium content of at least 12 percent. This also lowers the achievable hardness values, such as a household knife's capacity to hold a cutting edge.

Almost all possible alloys can be used for forging. We can normally forge articles for daily use, such as handrails, gates, and crosses for graves, by using standard structural steels. Forging corrosion-resistant steels has meanwhile gained some importance, since it eliminates the need for corrosion protection. The register of European steelmakers lists over 2,500 steel grades.

Development of Steel Production

Simple, hardenable steel was already used by the Hittites about 3,500 years ago, such as to make weapons.

In ancient times and in the Middle Ages, the ore was converted in pitlike charcoal-fired furnaces (smelting ovens) at temperatures of about 2,282°F (1,250°C) into a doughlike condition (smelted). The smelting product was called iron bloom, which was not melted. The slag was expelled from the bloom by several rounds of heating and forging. The product was an inhomogeneous steel of varying carbon content and was without essential components from other alloying metals (bloomery iron / bloomery steel). In the thirteenth century CE, the charcoal-smelting furnace (bloomery furnace) was developed in Europe. Using a bellows made it possible to attain a higher processing temperature, which made it possible to melt iron. The product of the bloomery, called a Stückofen in Austria, is the early pig iron (cast iron). The

pig iron was brittle and could not be forged due to its high carbon content. It had to be "decarburized" by welding together and forging a "bundle" of pig iron pieces, which burned and "pressed" out the carbon, slag, and other companion elements. This process was used until blast furnace technology was discovered, which made it possible to make liquid pig iron. Further processing the pig iron to burn out unwanted metalloids is also referred to as refining. The combustion sequence starts with the base elements, up to iron. Copper, which is a denser element than iron, cannot be removed by refining. This is a problem especially for scrap processing, such as of copper cable remnants.

In the puddling furnace (around 1780), charcoal was replaced by hard coal. Another milestone was the discovery of air preheaters (hot blast stove). This made it possible to significantly reduce fuel consumption. In the second half of the nineteenth century, great progress was made in steel production. The Bessemer process (Bessemer converter) and the Thomas process were also discovered during this period. In these processes, the combustion air was blown into the bottom of the converter. These methods significantly increased the quantity produced.

The Siemens-Martin process was also developed during this time and continued to be used into the second half of the twentieth century. The combustion air and the fuel gas

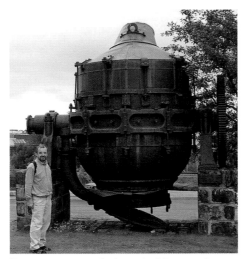

Bessemer converter in the park of the central Swedish city of Sandviken. This was used in the Sandvikens Järnverks AB steelworks. The book's author is standing to the left in the picture.

were preheated in a gas-fueled process that reached high temperatures. Electric furnaces have been in use since about 1900. Today, the usual refining method is the basic oxygen process (Linz-Donawitz process), in which oxygen is blown into liquid pig iron. The method is characterized by its short duration.

In the Middle Ages there were many hammer tool forges driven by waterwheels along the streams and rivers, where the pig iron was "hammered" until it became forge steel (forged steel). Many local names date back to this time (*Gußwerk* [*gießen* = to cast], *Hansenhütte* [*verhütten* = to smelt], *Hammerhäuser*). The production methods

were based mainly on empirical knowledge and differed according to location (e.g., England, China). As a result of the Industrial Revolution (which began with the invention of the mechanical loom in England), knowledge of how to produce steel of sufficient quality and quantity was a key technology.

For this reason, appropriate educational institutions were established in Europe (the "Steiermärkisch-Ständische Montanlehranstalt" in 1840 by Archduke Johann in Vordernberg, from which the Montanuniversität Leoben, Austria's national mining university, developed). In Europe currently, there are about 2,500 standard steel grades. The annual world production of steel amounted to about forty million tons in 1900 and rose to 1.55 billion tons by 2012. Steel is almost completely reused and can be fused practically any number of times.

Steel—Structure and Properties

Steel is among the iron materials. At room temperature, the pure iron atoms are arranged in cubic form (crystal lattice). There is an iron atom at each corner of the cube and in its center. This arrangement is called a cubic body-centered lattice. The atomic distance to the cube edge is 2.86×10^{7} mm.

When heated above 1,672°F (911°C), the atomic order is transformed from a cubic body-centered to a cubic face-centered lattice. Outside the cube edges, there is now an iron atom in every level of the cube, and

the iron atom in the cubic cavity is gone. The atoms in any one cube have changed from nine to fourteen. This results in a change in volume, and the lattice spacing is now 3.63 × 10⁻⁷ mm (2.86 × 10⁻⁷ mm in the case of the cubic body-centered lattice). In this state, thermal expansion is greater than in cubic body-centered iron.

Explanation of Terms

Austenite: Can absorb carbon atoms in solution. Model concept: austenite has a cubic face-centered structure, and in the center of the "structural cube" is a carbon atom.

Ferrite: Iron with cubic body-centered crystal lattice, 100 percent content of pure iron; with increasing carbon content the ferrite content decreases in favor of perlite.

Perlite: Has a structural area made of cementite (Fe_3C) and ferrite.

Cementite (Fe3C): Metallographic name for iron carbide, which is hard and nondeformable. γ-Mixed Crystals: As it cools from the melted state, solid mixing crystals are formed that have a pine-tree-like shape. They are also called dendrites.

The basic relationships of the iron-carbon alloy (= steel) are schematically illustrated in **the diagram on p. 56**, greatly simplified. The influence of unwanted metalloids has not been taken into account; this diagram was prepared under laboratory conditions. Nevertheless, you can deduce

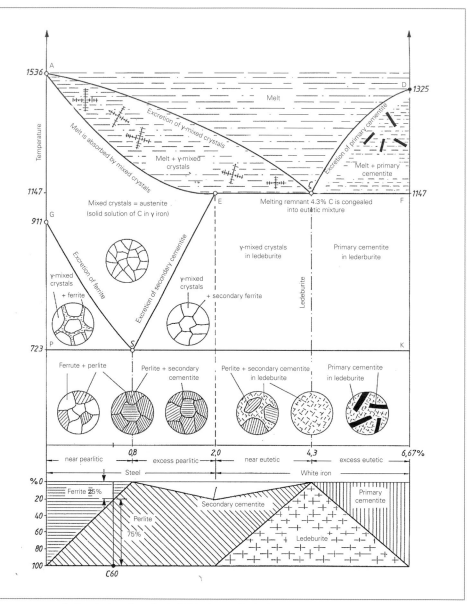

There are no conclusive designations for individual areas in the iron-carbon diagram. Some of these were named after scientists who studied steel metallurgy (Sir William Chandler Roberts-Austen [1843–1902] for austenite, or Karl Heinrich Adolf Ledebur [1837–1906], who discovered the eponymous ledeburite).

Cubic body-centered

Cubic face-centered

○ Iron atom at center of cube

● Iron atom at corner of cube

○ Iron atom at center of cube face

Possible arrangement of the iron atoms in the crystal lattice. The arrangement is determined by the alloy contents and the temperature present. There is hardly space in the cubic body-centered crystal lattice for carbon; in the face-centered crystal lattice there is space for a carbon atom.

from it that the structure and composition of steel can vary greatly depending on the temperature and the carbon content. From this diagram you can also deduce what the favorable areas are for forging and heat treatment, such as hardening, tempering, or annealing. It is known that austenite (area above the line G–S–E) is particularly malleable. Therefore, the target forging temperatures are just above this line, whereby it should be recognized that the required forging temperatures decrease with a carbon content up to 0.8 percent (point S in the diagram). With increasing carbon content, the forging temperatures rise again.

For fire welding, the range in which melting and mixed crystals occur is interesting. Again, it should be noted here that the carbon content has a significant influence on the required working temperature.

The illustrated iron-carbon diagram shows the elementary relationships for a slow cooling of the pure alloy of iron-carbon, which in practice occurs only in the laboratory. In fact, other, partly unwanted elements such as sulfur, phosphorus, and nitrogen oxides (as iron oxide in the form of the smallest slag inclusions) are also present in the steel. The iron-carbon diagram and consequently the properties of the steel are modified by these—and specifically used— alloying elements.

Other Elements in Steel (Metalloids)

The most undesirable secondary components in steel are referred to as metalloids. These are mainly silicon (Si), manganese (Mn), phosphorus (P), and sulfur (S). In some cases these elements are deliberately added. For example, small amounts of sulfur can result in brittle slivers when a workpiece is machined by turning or milling; this is an advantage for manufacturing with automatic cutting machines (machine steel). However, these sulfur-containing steels cannot be polished to a high gloss.

Metalloids Mode of Action
Silicon

Silicon increases strength and hardness, but even at low levels it also impedes welding, especially fire welding.

Manganese

This element is also used as an alloying element. Manganese gives rise to special properties; manganese steel does not become hardened by quenching after it is heated, but can even become softer due to structural change. The term "manganese hard steel" refers to strain hardening of this steel. Thus, for instance, when being hammered in a beater mill to crush the rock, solidification occurs on the impact side, which leads to high wear resistance. The same is true for excavator teeth. Manganese steels are not suitable for

Manganese ore in the form of a manganese nodule; manganese nodules are found on the bottom of the ocean. Currently, it is not possible to mine these economically. The manganese nodule shown was found in the Voralpen region (primeval sea).

woodworking tools, since wood is too soft to cause strain hardening.

Phosphorus

Phosphorus causes an increase in notch sensitivity. In steel, the phosphorus content should not exceed 0.06 percent.

Important Alloying Elements

The purpose of alloying is to improve certain properties of the steel.

For high levels of stress, such as for aeronautical and space applications, we use multiple forged parts. Here, pure carbon steels are insufficient, and through targeted alloying with other metals and a corresponding heat treatment, it is possible to manufacture so-called custom-made materials, such as steels with higher

temperature resistance or corrosion resistance. The most-important alloying elements **are briefly described below.**

Chromium

Chromium is one of the most important alloying elements for steel. Chromium-alloyed steels undergo an increase in strength and hardness. A chromium content of more than 12 percent creates corrosion resistance (e.g., for cutlery, cooking utensils). To achieve a high degree of hardness, a high carbon content is also required (chrome eats the carbon).

Examples of chrome-alloyed steels for daily life are eating utensils and cooking pots.

Nickel

Nickel steels are very tough and work well for tempering and quenching. They are used mostly in combination with chromium.

Other Alloying Components

Molybdenum, copper, vanadium, tungsten, etc.

Classification of Steels

Since steel can contain, in addition to carbon, many more alloying elements in the most diverse combinations, there are almost as many different steels, which often differ only a little in their properties. To obtain a clear overview, classifications are made on the basis of various criteria, such as according to application area for structural

steels, cold-working steels, or hot-working steels, or according to the heat treatment for case-hardened steels (edge layers are fortified with carbon, so that nonhardenable steels can be hardened in the edge layers), heat-treatable steels, etc.

All alloying components can be precisely determined by means of metallographic processes, but these are not generally available.

Designation of Steels

Steels are also designated according to standards. The steelmakers usually also use their own designations. Designation by material numbers and designation according to essential alloying elements are generally used, independent of the company.

Example 1: Unalloyed structural steel, E 295, material number 1.0050. "E" stands for engineering steel, minimum yield strength is 275 N/mm^2, and tensile strength is 470–610 N/mm^2.

This steel used to have the designation St 50, with a tensile strength of 50 kp/cm^2. Since the yield strength is more significant for construction than tensile strength is, the yield strength was passed over for the designation. Structural steels are processed without further treatment.

Example 2: C 45; heat-treated steel with 0.45 percent carbon.

Example 3: Tool steel for use in punches and shears, material number 1.2101; digit "1." stands for steel, the next two digits

denote the steel grade ("21" stands for tool steel with the alloying elements chromium, silicon, and manganese), and the last two digits (01) serve to further distinguish this type of steel.

Designation of this steel according to the essential alloying constituents with a total alloy content of less than 5 percent: 62SiMnCr4, which means 62/100 percent carbon, equals 0.62 percent carbon; the digit after the alloying components states the fourfold amount of the first alloying component (i.e., 4/4% = 1% silicon). Manganese and chromium are present in small amounts in this alloy and are not specified in more detail. The Böhler company's internal designation is K 245, where "K" stands for cold-working steel.

For a total alloy content of less than 5 percent, the following levels apply: carbon dioxide, 1/100; manganese, silicon, chromium, nickel, cobalt, and tungsten, ¼; for all other elements, 1/10.

With a total alloying proportion of more than 5 percent: an X is used to indicate an alloy content of over 5 percent, and the alloying components, except for carbon, are indicated in percentage.

Example 4: X105CrCoMo 18-2, material number 1.4528, is a stainless chrome steel 105/100 percent carbon, 17.3 percent chromium (rounded to 18%), 1.5 percent cobalt (rounded to 2%) and 0.40 percent silicon, 0.40 percent manganese, and 1.10 percent molybdenum. From the material number we recognize that

Example: Die-forged machine part in the appropriate die half. Finishing is done by machining.

the first digit (1) means steel, the next two digits (45) mean stainless steel, and the last two digits (28) serve as internal classification. This steel is used for knives, surgical instruments, and corrosion-resistant rolling bearings. The hardening temperature is 1,922°F to 1,976°F (1,050°C–1,080°C), and the tempering temperature is between 212°F and 392°F (100°C–200°C). The hardening agent used is oil.

This brief and incomplete introduction to steel designation shows that the exact composition of the steel cannot be exactly represented by the steel designation alone. In addition, a profound expert knowledge is necessary to be able to estimate the influence of individual alloying elements on the steel properties. We find that in most

cases, just a few grades of steel are sufficient for practical use.

Depending on what use will be made of the forged piece, different alloys can be used, such as nickel based.

A good degree of workability (malleability) is primarily important for forging ornamental and consumer goods. This is achieved by a low carbon content of the steel.

Methods for Determining Steel Grades

The attraction of forging often lies in giving new use to a used piece of metal or a piece of scrap by forging it. If it is only a matter of making ornamental pieces, you can determine whether your steel can be forged

well by heating and hammering and bending the workpiece some. If, however, you want to make tools, you must be able to give the steel a heat treatment, such as hardening. To do this, you should be able to estimate in advance which type of steel you are dealing with. In some cases, you can also hear differences in the quality of the steel from the sound of the workpiece. Soft steels sound dull, while hard steels have a bright sound (anvil).

Spark Test

A simple but only rough estimation can be made by the spark test. When it is ground, each type of steel emits its specific shapes of spark ray and spark. It is best to perform this experiment on a bench grinder or an angle grinder; a dark room or a dark background works best. The process provides only guideline values, and in most cases, you won't be able to fulfill any expectations by this simple procedure. This method is also used to avoid confusion about the material. You have to acquire some practice in observing the sparks from grinding to be able to recognize significant differences. In addition, material residues from previous grinding samples can falsify the result. For precise work, a new grinding wheel must be used for each workpiece.

The images on this double page show some characteristic spark patterns for different grades of steel.

Spark pattern of a steel with 0.1 percent carbon content. The spark ray does not show any ramifications (secondary ray)

Unalloyed tool steel with about 0.5 percent carbon. The higher carbon content is shown in the ramifications of the individual rays and in the increased "little stars." This steel can be hardened.

Determining Steel Grade by Spectral Analysis

This is a fast and reliable method to determine the chemical composition of a workpiece. However, it requires access to a materials science laboratory.

An arc is ignited with argon gas between a tungsten electrode and the test specimen, and the sample surface is vaporized. In the form of the bundled light of all elements, the emitted rays are guided into the optical detector of the spectrometer. There the light is broken down into its individual wavelengths and analyzed. The analysis is done by computer, which reports the evaluation of the types of steel.

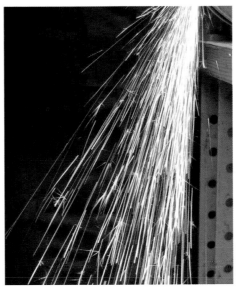

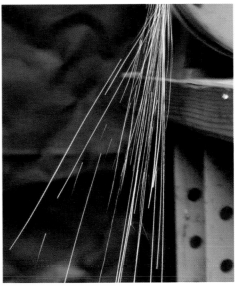

Unalloyed tool steel with about 0.9 percent carbon. The higher carbon content shows even more "little stars." This steel can be hardened to a high degree.

Spark pattern of a construction steel (flat steel) with lower carbon content

Stainless steel with at least 12 percent chromium

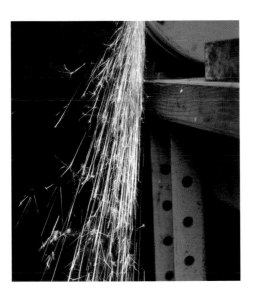

Picture page 60, bottom: Hot-working steel, material number 1.2343—X37CrMoV5-1. The spectral analysis shows: 0.4 percent carbon, 5.35 percent chromium, 0.43 percent vanadium, 0.3 percent manganese, 0.1 percent silicon. This steel can be used for spalling hammers, dies, and other tools used in contact with red-hot workpieces.

Picture right: Spark pattern of a high-speed steel with a high content of chromium, tungsten, molybdenum, and cobalt. The spark pattern is dark red and has hardly any ramifications. Easily distinguishable from other steel types.

Picture left: Spark test on a crampon with a carbon content of 0.4 percent (spectral analysis). The spark pattern is similar to that for 0.5 percent carbon.

Example:

Round steel, 0.6-inch (15 mm) diameter

The spectrum analyzer output: C 55, material number 1.1203. The most-important components from the analysis are 0.536 percent carbon, 0.246 percent silicon, 0.638 percent manganese, 0.017 percent chromium, and 0.044 percent vanadium. Other elements such as aluminum, nickel, sulfur, and copper are present in amounts below 0.01 percent. The elements occurring in the smallest quantities were probably introduced into the steel by scrap processing.

Corrosion-Resistant Steels

These steels are also popularly referred to as rust-resistant steels (Nirosta) or stainless steels. They have a chromium content of at least 12 percent and are sometimes also referred to as chrome steel. In principle, it is possible to forge chrome steel, but it is used only in special cases for artistic forging work. This steel can often be interesting for making articles for daily use, such as knives. The high chromium content considerably reduces hardenability, so the carbon content must be significantly increased (up to 2%) to achieve a high degree of hardness. Among metallurgists, the rule applies that chromium eats up the carbon! If you want to obtain the highest possible degree of hardness (resistance to penetration by another body), pure carbon steels are preferable.

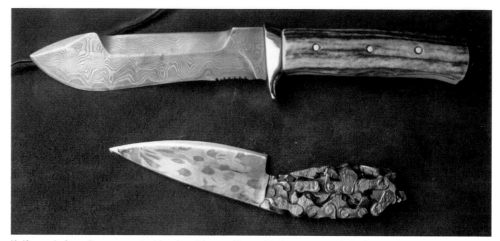

Knife made from Damascus steel (*top*) and from a fire-welded power saw chain (*bottom*). Drive chain links and sprocket teeth are made of different grades of steel, which creates this dappled structure.

Damascus Steel

We understand Damascus steel to mean a material made of different grades of steel (soft/hard). These materials are fire-welded together in several layers and then forged. This yields very finely textured surfaces, and their effect can be enhanced by polishing and etching. The combination of soft steel and hard steel creates a good capacity to hold an edge and high degree of elasticity. There are many methods of making Damascus steel, and steel designations often refer to the place where the respective process was developed. It is the swords (Samurai swords or swords from Asia Minor) made from Damascus steel that are best known. Less well known are the knives, gun barrels, and other objects made from Damascus steel. Cheap imitations are often available, which were given a deceptively similar surface to Damascus steel by etching and dyeing.

Inaccurate definition of terms still fosters such negative situations. The technical literature speaks of Damascus steel, made by fire-welding at least two different grades of steel together. The number of different steel layers on top of each other contributes decisively to the appearance of the finished workpiece.

Nonferrous Metals (N-F Metals)

These metals are used for technical parts with special requirements.

Copper

Copper has been known significantly longer than the material iron. Characteristic properties include primarily its good conductivity for heat and electricity. Copper in its original state can be easily cold-worked and it solidifies gradually. This process can be reversed by soft annealing. The importance of copper forging is shown in such professional terms as coppersmith (boilermaker) or street names such as *Kupferschmiedgasse* (Coppersmith Lane).

Copper is sometimes used to make parts for artistic forging. Copper's color provides a lovely contrast to the black of wrought iron. For example, copper can be used to make rosettes or drip catchers for candleholders. Since copper is very soft and flexible in its delivery condition, it can be cold-worked. After repeated cold working (bending), the copper becomes brittle. It can be brought back to its soft original state by using an

Silver jewelry. The work of the goldsmith is essentially different from a blacksmith's work. Many jewelry pieces are made by casting.

Bracelet—example of copper work using embossing tools (specialist head teacher Hannes Putzgruber, Höhere Technische Bundeslehranstalt Kapfenberg).

annealing process. Copper has a melting point of 1,983°F (1,084°C). Its forging temperature ranges from 1,112°F and 1,292°F (600°C–700°C). Since copper does not show the annealing colors we know for steel, you can determine its temperature only by measuring it. As a rule, after a few attempts, you will be able to get the empirical values.

Titanium

Titanium is the material that exhibits strength values like those of steel at a significantly lower density than steel. By comparison, aluminum has only about one-third the density of steel, but its strength values also reach only about a third of those for steel. Titanium therefore works very well for forging tools with a low weight.

Its melting point is 3,034°F (1,668°C), higher than that of iron and steel. Its density is about 60 percent of the value for steel. A disadvantage is the high price of titanium and titanium alloys. In addition, steel is much more available in different dimensions than titanium is. Using titanium for forging is therefore rather restricted to fanciers of this material.

Silver

Silver is also soft and easily formable (often referred to as ductile). It melts at 1,764°F (962°C). However, due to its good workability, it is cold-worked at room temperature. Due to its high price, it is used almost exclusively for jewelry. Smiths often also work with silver alloys.

Gold

The most precious of metals at the same time has the highest degree of density of the metals (about 2.5 times the density of iron). This also affects pricing, since you always require a specific volume and not a

Solid gold combined with quartz

specific weight. It is fashioned exclusively at room temperature to make jewelry and ornaments (goldsmithing). The melting point of gold is 1,947°F (1,064°C).

There are many versatile ways to apply the fashioning process for forging. Almost all metals and alloys are more or less easy to forge.

Heat Treatment of Steel

The properties of steel are largely determined by the proportion of its alloying components. In addition, selective heat treatment of a workpiece plays an important role in the final material properties of the workpiece. There is also an interaction between the contained alloying elements and the heat treatment processes that can be derived from them. The processes used during heat treatments can be abrupt or can take a long time, depending on the method.

Heat treatment includes the terms "hardening," "tempering," and "annealing."

Hardening

We understand hardness as the resistance to penetration by another body, but this professional description is of little immediate use. Hardening is often used to improve a tool's capacity to hold an edge or even get the edge at all. A chisel or a metal drill would become dull immediately if it wasn't hardened. Simply presented, steel is hardened by heating the steel to high temperatures (hardening temperature) and rapidly cooling the workpiece. The hardening temperature and necessary rate of cooling depend essentially on the composition of the steel and the desired material properties. For forging, you would want tools such as chisels, knives, or axes to be heat-treated in such a way that they keep a good cutting edge for as long as possible. As the hardness increases, the material's elasticity and ductility decrease.

High degrees of hardness can be easily achieved with a high carbon content. At the same time, the material becomes very brittle (chilled). In the extreme case, if the workpiece falls from the workbench to the floor, it could easily break. By adding more alloying elements and appropriate cooling, you can achieve better results from hardening. Steels with a carbon content of less than 0.4 percent cannot be hardened. Repeatedly heating the workpiece in the forge fire makes it possible to change its carbon content, especially in the outer layers. The hardening temperature depends on the carbon content. It lies slightly above the minimum forging temperature for the material (**line G–S in the iron-carbon diagram on p. 56**).

Heat the area of the workpiece to be hardened to red hot (depending on the carbon content). Steel suppliers issue data sheets indicating the heat treatment temperatures. Care must be taken to ensure even heating; that is, the heating process should not be interrupted immediately after the workpiece surface has reached red hot. If the heating time is too short, the center of any thick workpiece will not have reached hardening temperature. After sufficient even heating, quench the workpiece by dipping it into cold water. If the workpiece is swirled around while it is cooling, this results in even cooling; otherwise, insulating steam bubbles form on the workpiece surface. The degree of hardness that can be obtained for a workpiece depends on how rapid the cooling process is. The cooling speed decreases going from the outside inward, so the hardness also decreases inward from the outside. However, this effect applies only to workpieces with high wall thicknesses. Highly alloyed materials must be quenched more slowly, which can be done in an oil bath (oil hardening) or in a steam of air (air hardening).

Complex processes take place in the steel during cooling. The formation of different types of microstructures depends on the temperature and timing. These are shown in time-temperature transformation diagrams (TTT diagrams). Steelmakers provide these for various alloys.

A simple quenching in water or oil works well for simple workpieces and gives satisfactory results. Highly alloyed workpieces must occasionally be cooled very slowly in a furnace atmosphere.

Tempering

We understand tempering as a further heat treatment after hardening, in which the already hardened workpiece is heated once again. This decreases the hardness and

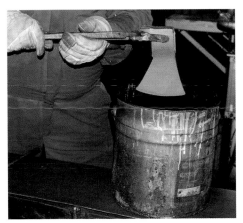

Hardening an axe in an oil bath. The cutting edge is finished by grinding after the heat treatment. The axe is not completely quenched, and the area in the middle and the casing still remain weakly glowing and supply the warmth for tempering.

increases the toughness. The ratio of hardness to toughness can be changed by how high the tempering temperature is. The correct tempering temperature can be determined by the color of the workpiece (tempering colors).

After hardening, the surface is usually scaled, which hinders your view of the workpiece. Use a grindstone or file to remove the layer of scaling. Then heat the hardened section over a gas flame or the forge fire until the desired tempering color is reached. Then quench it immediately in cold water. By swirling the workpiece around, you get even cooling in the water bath. Tempering with residual heat is a very simple method of tempering. To do this, heat the area beyond the section on the workpiece to be hardened during the hardening process, and quench only the front piece, so that one section, between the part to be hardened and the unhardened part, still remains slightly glowing. After removing the scale layer, you will now see how the hardened section is reheated by the residual heat in the in-between section. When the place to be tempered has reached the desired tempering color, then quench it. By this method you can increase the toughness, going away from the cutting edge.

While heat treatment can be planned exactly and reproducibly by metallurgists in industrial production, the hobby blacksmith has to gain his own experience. Too low

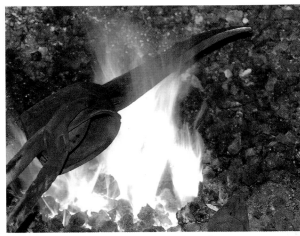

Tempering the bar of a sappie over the forge fire

tempering temperatures lead to fracturing; too high tempering temperatures lead to deformation of the cutting edge or bending the cutting part.

The right tempering temperature lies in between, but only for any specific alloy. For a chisel, you have reached the correct tempering temperature when the blade turns blue.

However, you can also dispense with the hardening and tempering processes by using high-carbon steels, which reach their required hardness and toughness when cooled in the air.

Annealing

There are different types of annealing. Here we describe only those annealing methods that are important for forging.

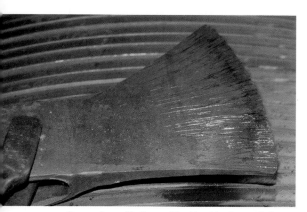

Tempering with the residual heat in the workpiece. Do not quench the workpiece completely, but instead only in the cutting-edge portion. The rest of the workpiece must remain at a higher temperature than the tempering temperature, so that the quenched section slowly rises to the tempering temperature. You can see on the axe how the blue area spreads out toward the cutting edge. To be able to see the tempering colors better, remove the scale from the surface by hand with a grindstone. When the cutting edge has reached the correct tempering color, quench it completely.

Stress Relief Annealing

Internal stresses (residual stresses), which arise, for example, due to cold bending, welding, or uneven cooling, should be eliminated. Internal stresses can already lead to breakage even at low levels of stress.

Procedure: Heat the parts slowly to about 1,112°F (600°C) and keep them at this temperature for several hours. Then cool slowly and evenly. The method can be used only if you have an appropriate furnace available.

Normal Annealing

Repeated shaping in a cold or warm state causes changes in the structure that can adversely affect mechanical properties.

Normal annealing restores the "normal state" of the material. This process can be done again and again.

Procedure: Depending on the carbon content, heat the piece slowly to about 86°F (30°C) above the minimum forging temperature and keep it at this temperature until the entire workpiece is at the same temperature. Then cool the workpiece slowly so that there is no increase in hardening.

Heat Treatment Errors
Example 1:
Too High an Increase in Hardening

The workpiece breaks under bending stress because it has become too hard and, as a result, has not been stretched enough. During tempering with residual heat, the area of the fracture was heated so much during the second quenching process that the hardness of this area was increased again. In this case, the heat treatment process must be repeated at a lower residual heat. If only a small section of the point is heated to hardening temperature and quenched, there will not be any increased hardening in the rest of the chisel. The tempering should then be done either over a gas fume or over the forge fire.

Example 2: Hardening Cracks

Hardening cracks result due to cooling a high-carbon steel too abruptly. In this case, a slow rate of cooling is required during hardening. Depending on the composition of the steel, in this case it should be cooled in hardening oil or just in the ambient air.

Determining Hardness

Hardness is defined as the resistance of a workpiece to the penetration of a harder body. The test methods do not require their own test specimens, such as for determining tensile strength, and can be performed directly on the workpiece. There are three different hardness indicators known in the metal industry, which are yielded by the test processes:
- **Brinell hardness (HB)**
- **Vickers hardness (HV)**
- **Rockwell hardness (HRC)**

These procedures were developed during 1900 to 1930 and are standardized.

Hardening error on a flat chisel

They are still used and there are certain limits to the application of each method. In all three processes, a penetrator is inserted into the workpiece, using a specific level of force. The hardness value is determined from the resulting impression.

Brinell Hardness (HB)

A ball is pressed onto the workpiece, using a specific test force. This produces a spherical cap. The hardness can be determined from the test force and the impression surface. Since different ball diameters and different test forces are used, Brinell hardness data can be compared with one another only if these were determined under the same test conditions. This test method is applied to materials of medium hardness.

Vickers Hardness (HV)

For this method, the penetrator is a blunt four-sided pyramid of diamond. This makes it possible to also measure the hardest materials. The diagonals of the impression

are measured on the specimen. The hardness value is determined from these very small diagonals and the test force.

Rockwell Hardness (HRC)

The Rockwell hardness test uses the penetration depth of the penetrator as a measure for determining hardness. The penetrator is a blunt diamond cone. This is a fast measurement method. Sometimes the hardness of kitchen knives is shown in HRC, such as HRC 55±2.

The maximum achievable hardness for steel is determined by the carbon content and the rapidity of quenching. There are conversion tables for the three different methods of measuring hardness. Approximate values for hardness: Vickers hardness is approximately ten times the Rockwell hardness.

Stress cracking on a splitting chisel

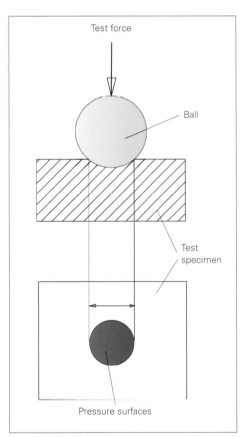

Principle of the Brinell hardness test

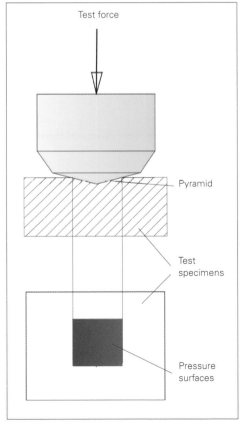

Principle of the Vickers hardness test

Further Information on Material Properties

These can be taken from data sheets and catalogs, which are made available by steelmakers or commercial companies. For tool steels, such as stainless steel, you can use the handbook from the Böhler company at www.bohler-edelstahl.com. The stated hardness and tempering temperatures are important for forging.

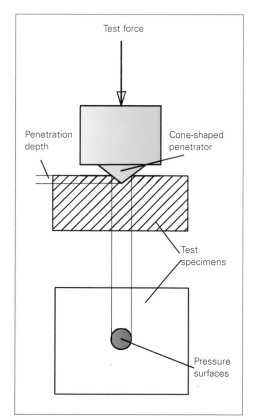

Principle of the Rockwell hardness test

Test force

Penetration depth

Cone-shaped penetrator

Test specimens

Pressure surfaces

Other characteristic properties include tensile strength and yield strength. The tensile strength in N/mm^2 indicates the tensile stress at which a test specimen breaks. The yield strength specifies the stress in N/mm^2 at which no permanent deformation occurs. In earlier steel designations, St 52 steel had a tensile strength of 52 kp/mm^2 (equivalent to 510 N/mm^2).

Example:

Details from a steel supplier:

Steel abbreviation C45
Material number 1.1191
Material group unalloyed
Tempered and quenched steel

Chemical composition in %

Carbon ... 0.42–0.50
Silicon ... max. 0.40
Manganese................................ 0.50–0.80
Phosphorus................................. max. 0.30
Sulfur .. max. 0.35
Chromium.................................... max. 0.40
Molybdenum max. 0.10
Nickel .. max. 0.40

Usage

For low-stress parts that require a high tensile strength, such as a pinion, connecting rods, gear wheels, and tools for agriculture and forestry

Properties

Good workability, can be tempered, conditionally weldable, can be surface hardened

Heat treatment

Hardening 820°C–860°C in water or oil
Tempering... 550°C–660°C for at least one hour
Hot forging.........................850°C–1,100°C
(forging temperature)

Mechanical properties
in tempered and quenched state

Yield strengthmin. 430 N/mm^2
Tensile strength650–800 N/mm^2
Ultimate strain min. 16%

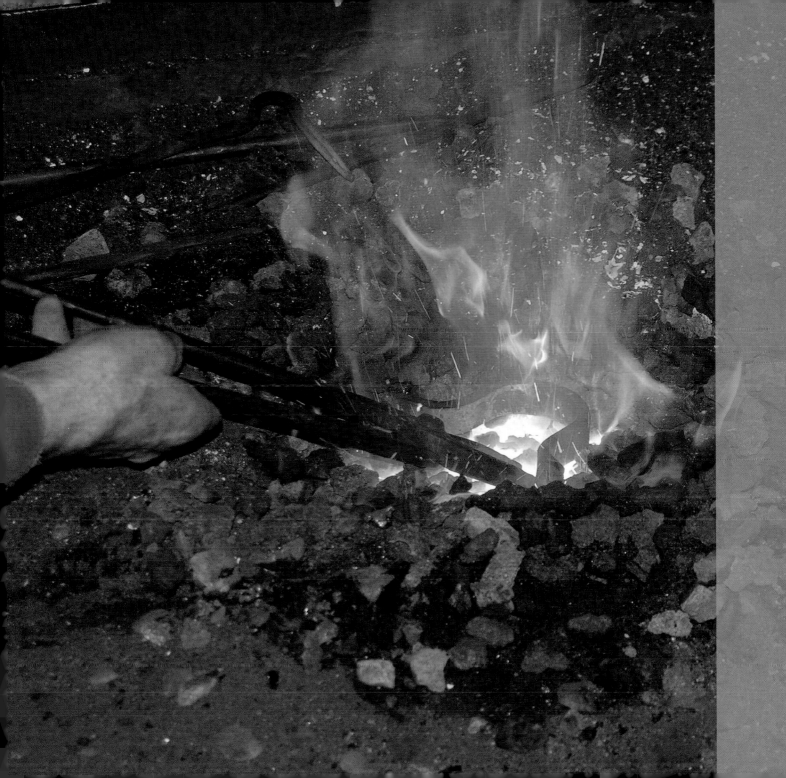

Forged Tools for Agriculture and Forestry

Many tools for agriculture and forestry were produced by hand in forging workshops. With increasing industrialization and automation, changes also went into effect here, but on a much smaller scale than those in machine production. Red-hot steel and powerful hammer blows still typify any modern smithy. Computerized design methods and simulation of production processes are widespread in mass production.

From sometime in the second half of the 20th century, village forges were generally being displaced by industrial production of tools and machinery. There was a smithy in almost every village—the village smithy.

Hammering shoes on the hooves of draft horses was an important part of smithy work. The draft horses were gradually almost completely replaced by tractors, and the stock of horses fell to a historical low between 1950 and 1960. It was only due to the newly emerging breeds of sporting horses that the number of horses increased again. This meant that more farriers were needed once again.

The following chapters describe some significant forged tools and equipment from the Alpine region.

The names often differ by region (such as *Hacke–Axt* [axe]). As a result of the progressive mechanization of work in

Forged hand tools for use in agriculture and forestry in the showroom of an Austrian forging company

agriculture and forestry, the need for tools for work done by hand shrank substantially. Only a few workshops still make tools for work done by hand in agriculture and forestry, with a large proportion of them intended for export. In many smaller workshops, production of such tools has been completely abandoned.

Scythes (Franz de Paul Schröckenfux GmbH)

There is hardly any agricultural implement as important as the scythe. Scythes, sickles, and

plows are found in many depictions of farmers. The scythe can also be found in art—as Death, who punishes people with a scythe.

In the Alps there were many scythe smithies, preferably on brooks and rivers to drive the machines by hydropower.

In addition to the many different regional designs for scythes, there are also special designs for the left-handed.

The essential requirements for a scythe are good cutting quality and, above all, the capacity to hold a cutting edge over a longer period of time. This is achieved by using a

high-carbon steel, for example with a 0.7 percent carbon content. The cutting-edge area is only 0.1 mm thick, and it is sharpened manually using a grinding stone (whetstone). If the cutting edge has been sharpened too much, so-called hammer sharpening is used to re-create a thinner cutting edge. The area is struck with hammer blows to create the necessary thin cutting edge. This cold working causes this area to solidify.

In the process of scythe making described in the following section, these tools are manufactured by hand from a single piece of flat steel in many work steps (about thirty work steps). High-quality scythes are still made in the traditional way, even if the number of work steps might be lower.

Meanwhile, there are still just a few scythe makers in Austria who manufacture scythes in large numbers, primarily for export. Even today, a lot of manual work and technological knowledge goes into making

Various designs for scythes. *Source: Scythe Museum Deutschfeistritz, Styria, Austria*

Types of scythes for the right- and left-handed. *Source: Krenhof Aktiengesellschaft*

a scythe. If originally the water-operated tilt hammer was the deformation machine in general use, it in turn was replaced by spring or power hammers.

Heating equipment has also changed. The forge fires powered by charcoal and bellows have largely been replaced by gas- or oil-fired furnaces. These ensure exact temperature control and even heating. This is especially important for heat treatment.

The starting product for forging scythes is rolled steel in square form (called a *Bröckel* or "chunk" in Austria) or flat steel. The advantage of flat steel is that you can cut out a preform (ingot) from it, which requires less fashioning than a square "chunk." For large quantities, it is worthwhile to stamp out the preforms. If you are making smaller quantities, gas cutting or plasma cutting is usually a better method.

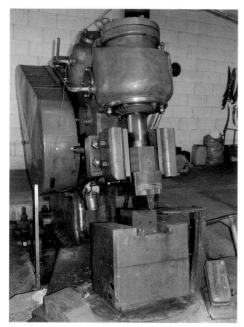

Pneumatic forge hammer for forging scythes.
Source: Franz de Paul Schröckenfux GmbH

In the first forging-work step, the connecting piece (tang) is forged to the scythe snath (also called a "scythe tree" or scythe handle). This part also bears the scythe's marking. Through several heats (multiple heatings), the preform is forged into the shape of a scythe by spreading. This is done by free-form forging with a power hammer and requires great skill of the blacksmith, above all to create consistent quality.

The back of the scythe must be forged further to make the thin scythe blade stable. This is the thickest area of the scythe, opposite the cutting edge. Straightening work is always necessary in between. Free-form forging does not create any exact contour, so the scythe is trimmed to create a uniform shape.

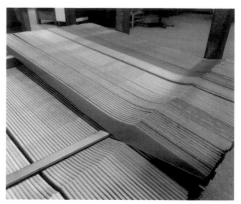

Preforms cut from flat steel (ingot). *Source: Franz de Paul Schröckenfux GmbH*

The distinguishing features of a scythe are its capacity to hold an edge well and great stability. For this reason, the scythes must be hardened, which is done by quench-hardening in an oil bath. Due to the high carbon content, quenching in water would cause the blade to cool too abruptly and subsequently cause hardening cracks.

The honing works any small indentations (ribbing) into the scythe blade. This also increases the stability of the scythe blade and makes the scythe look more pleasing.

The scythe blade surface is ground to make it gleam. Decorative honing gives the scythe blade a pleasing surface.

The scythes are hardened in an oil bath and are honed in two steps, so that the scythes arrive in the store ready for use. The scythes are given a rustproof lacquering and are color-painted at the mounting point. To

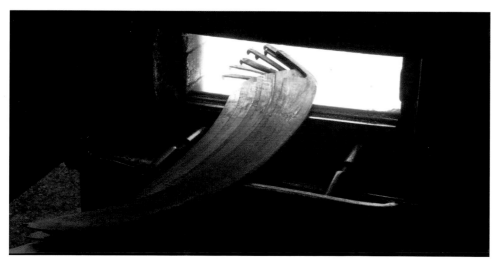

Heating the scythes in the forging furnace. *Source: Franz de Paul Schröckenfux GmbH*

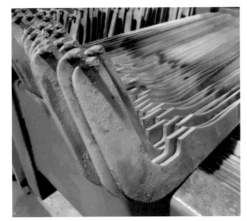

The tang is forged in the first forging process. *Source: Franz de Paul Schröckenfux GmbH*

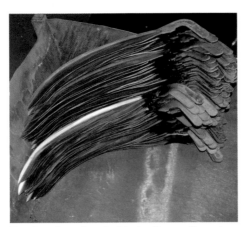

Free-form forged scythe blanks. *Source: Franz de Paul Schröckenfux GmbH*

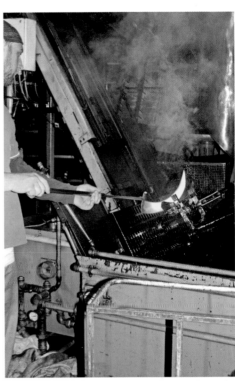

Hardening a scythe in an oil bath. *Source: Franz de Paul Schröckenfux GmbH*

Spreading out the scythe by free-form forging with a power hammer. *Source: Franz de Paul Schröckenfux GmbH*

Work step of honing. In the process, any small indentations in the scythe blade are smoothed out. *Source: Franz de Paul Schröckenfux GmbH*

protect against injuries and to protect the cutting edge, the maker adds a detachable plastic blade protector.

Axe and Hatchet

The terms "axe" and "hatchet" are not precisely distinguished from one another and are applied differently in different regions. In the Austrian Alpine region, the term *Hacke* is widely used for an axe. In archeology, an axe is a tool with a cutting edge and a head and an eye to fasten the handle. A *Beil* is a German name for a type of hatchet, but without an eye for the handle (such as a stone axe). In this case, the axe head and handle are fastened together with cords or straps. In contrast, for woodworking, the axe (*Hacke*) is guided with both hands and a stone axe only with one hand.

For a long time, axes were important tools for agriculture and forestry. With increasing mechanization, the need for axes has declined. Fortunately, there are still manufacturers of axes and related tools in Austria who can draw on centuries of knowledge.

Much of the work could and can be performed with different types of axes: chopping the cutting notch when felling a tree, chopping down small tree trunks, chopping off the branches, or trimming the trunk on the sides to produce squared timber or railroad ties.

The shape and weight are decisive when you are selecting an axe. Common weights are 800 to 1,500 grams. The most important quality feature is the axe's capacity to hold an edge, which is obtained by selecting the correct steel and the corresponding heat treatment—hardening and quenching and tempering.

The preferred grade of steel used is cold-work steel and tempered and quenched steels, such as material number 1.1730 or C45. The steel designated C45 contains 0.48 percent carbon, 0.3 percent silicon, and 0.7 percent manganese, as we can see from the tables. With 0.48 percent carbon, this steel is one of the hardenable steels. For hardening, the workpiece is heated to the hardening temperature of 1,472°F–1,526°F (800°C–830°C) required for this steel and quenched in an oil bath. This temperature corresponds to this steel being red hot. The tempering decreases the hardness and increases the toughness. A tempering temperature of 392°F (200°C) (tempering color white-yellow) yields a hardness of 54 HRC (Rockwell hardness test method, Rockwell hardness); at a higher tempering temperature of 572°F (300°C) (annealing color blue), the hardness drops from 54 to 47 HRC.

The heat treatment requires a great deal of skill by the blacksmith. High degrees of hardness result in a good capacity to hold

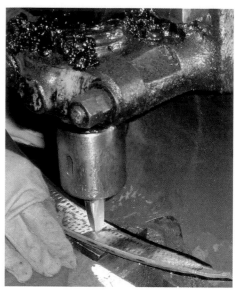

Polishing the visible side of the scythe by machining. *Source: Franz de Paul Schröckenfux GmbH*

Iron Age axe or Beil. Exhibition piece at the Riva City Museum on Lake Garda in Italy

Axes being manufactured at the Carinthian Hommerwerk. *Source: Himmelberger Zeughammewerk Leonhard Müller & Söhne GmbH*

piece by fire welding. This fire welding was replaced by the simpler and higher-quality arc-welding process. This method is sometimes demonstrated at forging demonstrations but is not very economical. As a rule, an axe that has become unusable due to wear will be replaced by a new one.

In another manufacturing method no longer in general use, a piece of flat steel was bent over a mandrel to make an axe and the two ends were fire-welded together. The cutting edge was welded by fire welding at both ends. In the next forging process, the axe was fashioned into the desired shape.

Making an Axe

This chapter was written in collaboration with Dipl. Ing. [graduate engineer] Josef "Seppi" Mutter, managing director of the Himmelberg Zeughammerwerk Leonhard Mutter & Söhne GmbH.

Axes are forged from a piece of steel in several work processes with repeated heating (each heating is also referred to as a "heat"; thus, first heat for first heating). Manufacturing an axe from several parts and fire-welding them together are now to be found only in demonstration forging or as a hobby. With the shift of material costs to

an edge, but also the risk that parts of the cutting edge can break off. As the hardness decreases, the toughness increases but the capacity to hold an edge decreases.

With modern-day production technology, axes are made from one piece. Previously, however, it was customary to make an axe out of two or three pieces. This was mainly done for cost reasons, since expensive tool steel was used only for the cutting edge. If frequent sharpening made an axe's cutting edge unusable (cutting edge is too thick), then this part was reforged and newly heat-treated. The common practice was to take off this part of the axe and attach a new

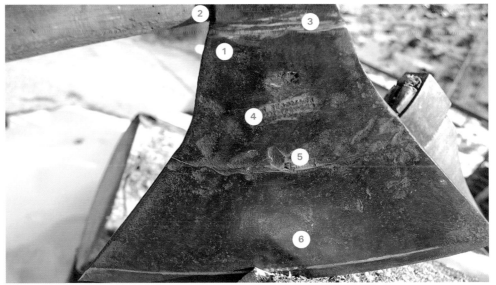

Old broad axe, made of three parts. Middle part of unalloyed (inexpensive) steel (*1*), hole for inserting the handle (eye) and handle (*2*), fire-welded section (*3*), name or mark of the manufacturer (*4*), fire-welded section (*5*), cutting edge of hardenable steel (*6*).

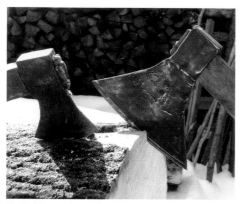

Typical logger's axe for trimming branches from conifers (*left*) and broad axe (*right*) for cutting round logs into square timber

a cold saw or is sheared off. In Austria, these sections are referred to as *Bröckel* (literally, "chunk").

These *Bröckels* are now brought to forging temperature and drifted (the opening, called the eye, is made for the handle). You still cannot recognize the shape of the axe after this process. The blade is forged in the following steps.

After this process, the dimensions of the blade do not exactly match the specified dimensions; the axe blade is larger and is therefore "trimmed" to the specified dimensions with a punching tool.

Burrs and excess material are removed by rough grinding and sanding. The cutting edge is fine-sanded to a rounded shape, which improves its capacity to hold an edge. Thus, the axe has retained its geometric

shape but cannot be used unless it is heat-treated. The hardening and tempering work steps follow. The axe is hardened in an oil bath, yielding a high degree of hardness but a low level of toughness. Quenching in water would cause the axe to cool too rapidly, and hardening cracks may occur. Tempering (low reheating) increases the toughness and decreases hardness.

The eye of the axe is not quenched and still retains residual heat, which is used for tempering. After the cutting edge has cooled to ambient temperature, take the axe out of the oil bath and remove any existing scale to create a bare surface so the tempering color is clearly recognizable. You can see the tempering colors as they progress from the hot area to the cutting edge. When you have reached the necessary tempering color (that

labor costs, the change was made to manufacturing an axe out of one piece.

The starting material to make an axe is square or rectangular bar steel in rod or bar form. This is cut to the required length with

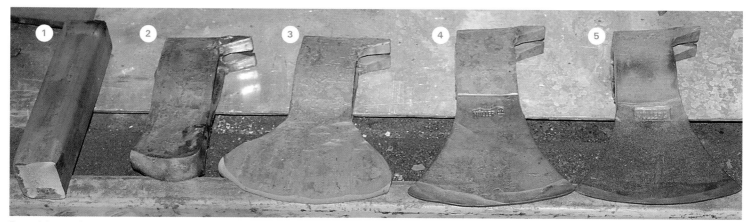

Essential steps for making a woodsman's axe. *From left*: Square steel bar (also known as a Bröckel or chunk) as the starting material (*1*). Drifted *Bröckel* with shaped nail claws (*2*). After the blade is forged out, the shape of the axe emerges, although with excess material (*3*). The final shape of the axe is created using a punching tool (*4*). Burrs are removed by grinding and sanding. Fine sanding creates a rounded shape. The axe is now heat-treated (hardening and tempering), followed by polishing the cutting edge (*5*). *Source: Himmelberger Zeughammerwerk Leonhard Müller & Söhne GmbH*

is, blue, corresponding to 572°F/300°C), the entire axe is cooled in an oil bath. This prevents any possible still-existing residual heat from subsequently heating the cutting edge above tempering temperature and changing the heat treatment process. Hardening and tempering are also referred to as tempering and quenching and are absolutely necessary to manufacture an axe.

The following final work steps are polishing the edge, painting, and fitting the handle. Sappie/Hookaroon (Himmelberger Zeughammerwerk Leonhard Müller & Söhne GmbH)

This forged forestry tool also has different names, depending on the place—it is called a sappie or hookaroon/pickaroon in English, and *Sappel* or *Sapine* in German. In principle, a sappie works by the lever principle. A sappie consists of the "eye," where the handle is inserted, and the spike, which ends in the tip. It is used for moving, turning, and lifting round logs. There are various common designs. The requirements for selecting the materials and heat treatment are similar to those for axes. This tool is usually made from one piece. The critical part of the sappie is its tip, and the blacksmith has to prove his skill while hardening and tempering it. If the tip is too soft it bends easily; a tip that is too hard breaks—the sappie has to be reforged and heat-treated. After it has been forged several times, a new part has to be welded on.

Starting materials warehouse for manufacturing axes and sappies. *Source: Himmelberger Zeughammerwerk Leonhard Müller & Söhne GmbH*

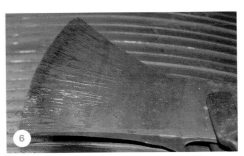

Cold-sheared *Bröckel* or chunks for making axes and sappies. *Source: Himmelberger Zeughammerwerk Leonhard Müller & Söhne GmbH*

Forging the blade for a woodsman's axe; this axe is asymmetrical. There are designs for the right- and left-handed. *Source: Himmelberger Zeughammerwerk Leonhard Müller & Söhne GmbH*

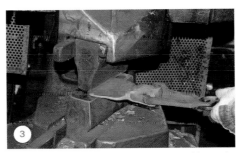

Punching tool for trimming a woodsman's axe. *Source: Himmelberger Zeughammerwerk Leonhard Müller & Söhne GmbH*

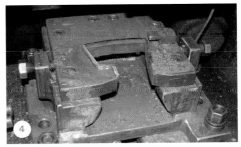

Hardening in an oil bath. The axe is brought to a high temperature in the gas furnace, and then the cutting edge is quenched in hardening oil. *Source: Himmelberger Zeughammerwerk Leonhard Müller & Söhne GmbH*

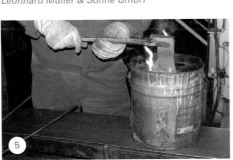

Tempering colors at the woodsman's axe. The coloring at the edge has just turned from yellow to blue. *Source: Himmelberger Zeughammerwerk Leonhard Müller & Söhne GmbH*

Forging a Sappie from a Square Block (Himmelberger Zeughammerwerk Leonhard Müller & Söhne GmbH)

Nowadays, sappies are forged from one piece. Similar to the process for an axe, the starting material is a square or rectangular piece of steel with about 0.45 percent carbon content. This ensures it can be hardened.

After warming up the *Bröckel* to forging temperature, it is then drifted and the "eye" is shaped in several steps by drop forging.

Enlarging and calibrating the eye creates burrs and excess material. These are removed by grinding and sanding. After the eye is finished, the spike is forged. Here again, there are many different common designs. This also applies to the tip.

The heat treatment—hardening and tempering—is done in a similar way as for an axe. The last work processes are grinding, sanding, painting, and inserting the handle.

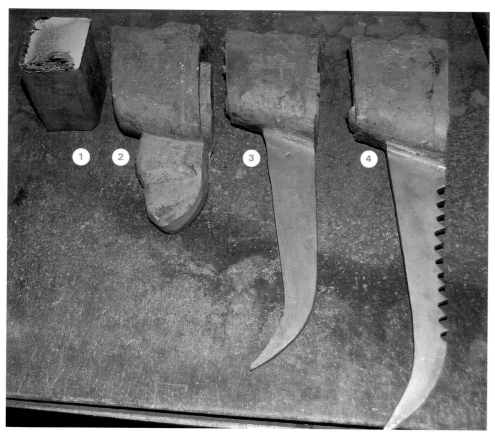

Work steps for forging a sappie. *Left to right*: *Bröckel* as the starting material for the sappie (*1*), drifted *Bröckel* with shaped spike (*2*), forged spike (*3*), variation in spike form (*4*). *Source: Himmelberger Zeughammerwerk Leonhard Müller & Söhne GmbH*

Forging a "Hooked" Sappie or Hookaroon from a Blank (Finer Sappel Manufacturer)

For this tool, we start out with a drop-forged preform with an eye and make it into a so-called *Schrägsappel* ("hooked" sappie), also known as a *Halbkrainersappel* ("half-carniolan sappie"). On a hooked sappie or hookaroon, the underside of the spike is designed in the form of a cutting edge. This is an advantage for a lot of work (it won't slip sideways). The name varies from region to region in Austria; it is also called a *Schneidsapin* ("cutting sappie") or *Zapin*.

The preforms have a preformed eye and a lug for the spike. This eliminates the work step of drifting. Originally, all the work processes were carried out by this forge itself. The work steps required on the preform are done by free-form forging (without dies) with a hand hammer, sledgehammer, and spring power hammer. The workpieces are heated to about 1,832°F (1,000°C) in the coal-fired forge fire and handed over to the blacksmith by a blacksmith's helper on the spring hammer.

From this, the spike is then forged out to its basic form in one heat.

Almost every forged tool is stamped with the name or the symbol of the manufacturer. Sometimes we can also learn the steel type or the name of the blacksmith from this mark.

At the end of forging, in the first heat, this manufacturer also hammers in the company name. This is also done using a spring hammer.

After the next heating (second heat), the cutting edge is forged. At the same time, the back side of the spike is forged out in the shape of a cutting edge. This prevents the sappie from slipping sideways when it is "biting."

The sappie eye is finished in the next work step. To do this, a slightly conical mandrel is hammered into the eye from both sides, using a sledgehammer. This creates the narrowest cross section in the middle of the eye. Attaching the wooden handle with wedges creates a solid connection between the sappie and handle.

Now follows the straightening and fine work on the cutting edge, as well as forging the tip of the spike. There are different ways to fashion the tip, depending on the intended use.

Since a sappie and axe are made from similar qualities of steel, the heat treatment given a sappie is comparable to that for an axe. For the sappie, about half of the spike

Drifting and final forging of the eye. *Source: Himmelberger Zeughammerwerk Leonhard Müller & Söhne GmbH*

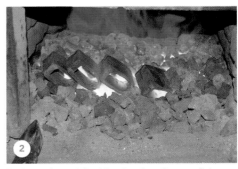

Preforms in coal-fired forging fire. *Source: Feiner GmbH*

Finished drifted sappie with calibrated eye and lug. *Source: Himmelberger Zeughammerwerk Leonhard Müller & Söhne GmbH*

Preforms for making sappies. *Source: Feiner GmbH*

Sappie eye after the last forging process. Ridges and burrs are clearly visible. *Source: Himmelberger Zeughammerwerk Leonhard Müller & Söhne GmbH*

Forging out the spike with the spring hammer. *Source: Feiner GmbH*

Basic shape of the spike. *Source: Feiner GmbH*

Forging the sappie tip on the anvil horn. *Source: Feiner GmbH*

Hammering in the company name with a spring hammer. This mark was also called a "Moach" (from *Marke*, the German word for mark or brand name) in colloquial Mürztal speech. *Source: Feiner GmbH*

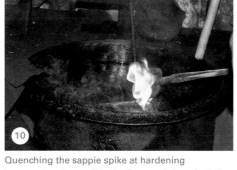

Quenching the sappie spike at hardening temperature in an oil bath. *Source: Feiner GmbH*

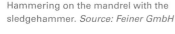

Hammering on the mandrel with the sledgehammer. *Source: Feiner GmbH*

Heating to the required tempering temperature according to tempering color, followed by quenching in a water bath. *Source: Feiner GmbH*

is heat-treated. Heating it to tempering temperature can be done over the forge fire.

After hardening and tempering, the sappie is finish-forged. Now grinding and painting work must be done to make the sappie ready for sale.

Crampons (Climbing Irons) from Styria

Doing forestry work in the Alpine region, with its steep slopes, requires a forester to be sure-footed, especially in the cold season with all the frost, snow, and ice. For this reason, crampons are often used above all in forestry as a climbing aid to prevent slipping. For many decades, drop-forged crampons were used almost exclusively. These crampons have only recently been replaced by more modern models. Production of these forged pieces has also fallen sharply.

Making Crampons
(Master Blacksmith Johann Loidolt, St. Kathrein an der Laming, Styria)

Starting material for these crampons is a bar steel with a rectangular cross section for the front and the back parts. The middle piece has a square cross section. The front and back parts are first prebent and then finished by drop forging. After the drop forging, the connecting points are drawn out to a point or punched. The rings to hold the fastening straps are not forged but instead are

purchased and loosely fastened on by bending the pointed ends. An approximately rectangular hole is punched into the front and back parts of the crampons; the pointed ends of the middle part are forced through these holes and bent over. The connections have a lot of play, to ensure that the crampons are very flexible.

Tools for Working the Soil
Forging a Planting Hoe (Krenhof Schmiedetechnik)

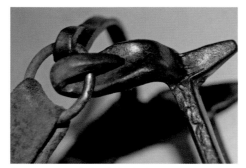

Rings are provided to hold the fastening straps. These and the three basic elements are connected together by drawn-out pointed ends, which are then bent over. It does not contain any welded, screwed, or riveted joints. There are usually eight spikes on a crampon.

Planting hoes are used to dig the holes for planting young trees in forestry. On one side, the tool is like an axe, and on the opposite side, turned at a 90-degree angle, it is shaped like a hoe. These tools are heavily stressed by the forest floor and above all by stones and rocks. High-quality planting hoes can be manufactured by forging, followed by heat treatment.

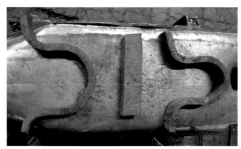

Preforms for drop forging. The parts for the front and the back are made of flat steel, which was fashioned into the required shape for the die at forging heat. The middle piece is made of square steel and is inserted diagonally into the die.

Forged crampon, attached to the shoe by straps (originally leather straps). The attaching method is one customary for these crampons.

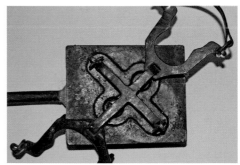

Die bottom for the middle piece with inserted middle piece

Preform in the die bottom

many more. According to the level of technical development, the use of forged pieces has changed. Almost all agriculture and forestry machinery includes forged parts, because these machine parts have excellent qualities.

Simple Forged Tools for Agriculture and Forestry

To represent the many forged parts that are used in agricultural and forestry work, we will describe here how some of these forged parts are manufactured.

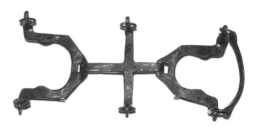

Crampons are essentially made of three parts, which are flexibly fastened together. Therefore, they are often referred to as linked irons. The part shown to the right in the picture is designed for the back of the shoe and has a clamp to prevent it from slipping out of the crampon.

The starting material is once again carbon steel, which is cut off from the bar at the required length by cold shearing or cold sawing.

The process of forge rolling is used to make these tools. They are worked into the desired shape in two rollings. By turning the rollers by less than one revolution, the forged piece is formed into the shape of the rollers. In terms of processing, this rather corresponds to a pressing or rolling process. This is a preferred method for making preforms for further forging processes.

Other Forged Parts for Agriculture and Forestry

We can provide only an incomplete list of such forged parts. To name just a few: shovels (also made from sheet metal), staples, hooks, forks, sickles, hammers, and

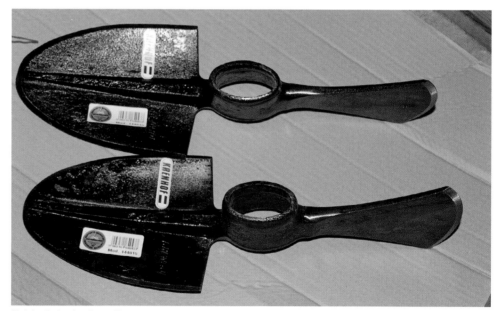

Finished planting hoes. The trowel-shaped part on the left side of the tool serves to dig holes, and the axe-shaped part on the right side can be used to hack through roots and turf. *Source: Krenhof Aktiengesellschaft*

Cramp Irons
(Clamps, Woodsman's Clamps)

This simple tool for joining wood cross sections such as squared and round timber is made of flat steel with a sample cross section of 1 × 0.2 inches (25 × 5 mm).

These cramp irons are machine-made in various lengths (250 mm, 300 mm) and are available for an inexpensive price at every construction supplier. For a long time, it was the local blacksmith's work to make these

Forging with a power hammer. *Source: Krenhof Aktiengesellschaft*

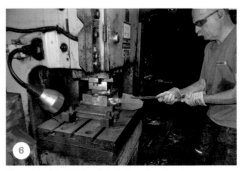

Drop-forging the hoe part of a planting hoe. *Source: Krenhof Aktiengesellschaft*

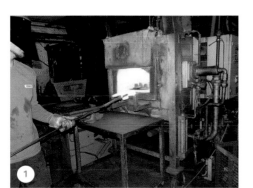

Making the tool requires several heating processes in gas- or oil-fired furnaces ("heats"). *Source: Krenhof Aktiengesellschaft*

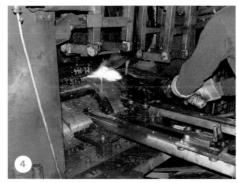

Another station for forge rolling. *Source: Krenhof Aktiengesellschaft*

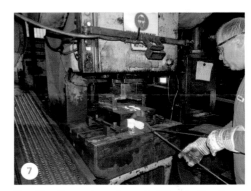

Punching the contour of a part of the planting hoe. *Source: Krenhof Aktiengesellschaft*

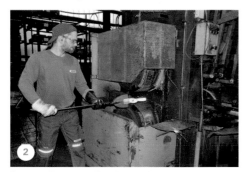

Forge rolling part of a planting hoe. *Source: Krenhof Aktiengesellschaft*

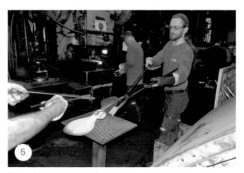

Transferring the preformed axe part to the next work station. *Source: Krenhof Aktiengesellschaft*

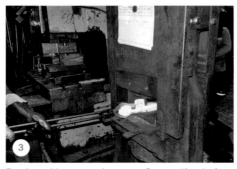

Final forging and calibrating the eye for inserting the handle. *Source: Krenhof Aktiengesellschaft*

practical woodworking tools. Often, various remnants of metal were used as the starting material, so that we can find such cramp irons of differing cross sections and lengths in old wooden structures.

The following section describes how a cramp iron is manufactured. Since this is a very simple piece of forging work, making a cramp iron can also be considered to be practice for other work. We used only a hand hammer in the manufacturing process that is described. Using a power hammer would considerably reduce the working time. The forging processes used to make a cramp iron include drawing the metal to a point and bending at 90 degrees. It is a good idea to indent the points and not let them run the width of the flat steel, since that would risk splitting the wood when the points are hammered in.

The flat steel is fullered at one end and forged to a point. The pointed end of the flat steel is heated again at the bending point, bent by 90 degrees in a vise, and straightened on the anvil. Do the same on the second end of the flat steel.

Sometimes there is a need for cramp irons with points twisted 90 degrees. To make them, heat the cramp iron in the middle to forging temperature and twist it by 90 degrees in a vise.

Making a cramp iron by hand is labor intensive. However, it allows you to make workpieces outside the commercial sizes.

This is also a good way to make sensible use of metal remnants.

"Logging Staples"
This forged tool is also a clamp that is used primarily to fasten chains and ropes to logs.

Making this simple forged piece by hand allows for a great freedom of design and individual adaptation to what you need.

A 0.8-inch-diameter (20 mm) round bar was used to make the pictured workpiece. The length can be affected by drawing out the point. In a rough approximation, it can be assumed that the length of the starting material is doubled by forging the points. A pointed length of 3.9 inches (100 mm) and an average distance between points of 2.4 inches (60 mm) yields an initial length of 5.5 inches (140 mm) (2 × point length = 200 mm + 80 mm bend length, yielding 280 mm; half of it = 140 mm).

The two ends of the workpiece are forged into a rectangular shape toward the center. This is done by stretching, using the hammer peen and flattening the surface. You can also use a planishing hammer.

After both sides are pointed, bend the workpiece in the middle over the anvil horn so that the wide sides of the rectangular cross section lie in one plane.

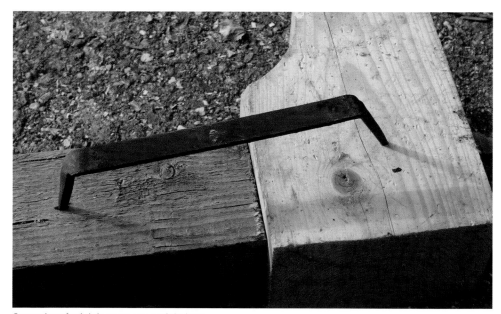

Cramp iron for joining two squared timbers

The last work process is removing any small surface defects by grinding, filing, or sanding. These workpieces are not usually given an anticorrosion coat.

Rings

Circular rings of various diameters and thicknesses are often used in agriculture and forestry. In a somewhat modified form, you can also make chain links in the same way.

Round steel bars are used most often, but square bars are also used. The rings can be made quickly when you use a pipe that has the necessary internal diameter.

Clamp the pipe in a visc and hold the end of the round bar, using locking pliers. Heat the round bar with the oxyfuel gas flame and bend it downward continuously over several turns. This method makes it possible to produce several rings in one work process. Working from the top downward has the advantage that it is easy to fasten the end of the bar to the pipe end. Thin, round bars can also be bent cold, but it must be noted that the elastic springback of the internal ring diameter will be greater than the pipe diameter.

The rings are now separated and straightened with a cutting-off grinder. The cutting point is fuse-welded and any excess welded material ground off.

An end of the flat steel piece, drawn to a point and fullered to make a cramp iron

Cramp iron point, bent 90 degrees in fullered section

Cramp iron made of 1 × 0.2 inches (25 × 5 mm) flat steel. Length of the cramp: 9.8 inches (250 mm), length of point: 3.2 inches (80 mm).

Cramp iron with 90-degree twisted points

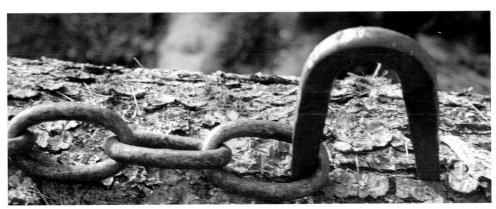

"Logging staple" to fasten a chain to a tree trunk

Pointed round steel bar, rectangular at one end, for a "logging staple"

"Logging staple" after bending. The two points can also be made parallel.

Hooks

Hooks are mainly used along with chains. Nowadays, hooks are industrially manufactured, are standardized, and have defined material and strength properties. For a long time, it was the blacksmith's work to make chains and the hooks and rings for them.

A chain hook is forged from a 0.9-inch-diameter (20 mm) round bar with 0.5 percent carbon content. First, the bar is reforged to a rectangular cross section. At the same time, the bar is stretched out, reducing the cross section.

The hook is cut out of the bar in such a way that even as it gets thinner, there is still enough material around the hole to fashion the loop to hold the chain.

After the circular cross section has widened into a rectangular cross section, use a small splitting hammer to make a slot. Then broaden this into a round cross section with a drift hammer.

After the piece is drifted, remove any excess material if necessary, and the fine work is done.

Chain hooks are highly stressed, so heat treatment is necessary. The steel used, with 0.5 percent carbon content, can be hardened by quenching in cold water. The necessary hardening temperature is 1,472°F–1,544°F (800°C–840°C). This creates a high degree of hardness and a low toughness. To increase toughness, the workpiece is

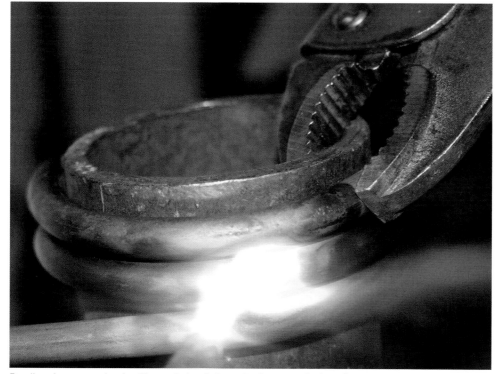

Bending rings around a pipe. The workpiece is heated using an oxyfuel gas flame.

tempered. The tempering temperature for this steel is 572°F/300°C (tempering color blue).

Forging the hook from one piece without welding seams and heat treatment creates a workpiece with the best strength properties.

The Farrier

The occupation of farrier has changed a great deal with the modernization of agriculture. For a long time, a farrier worked primarily with the large and strong draft horses. Since there was at least one farrier in nearly every village, the horses were brought to the local smithy for shoeing. Due to the sharp decrease in the number of draft horses or even the total disappearance of these animals, farriers have been deprived of their basic work. Many of these village smithies were abandoned, while some reoriented themselves; for example, becoming locksmiths or working with steel.

With the advent of equestrian and horse sports as popular sports for large numbers of people, the stock of horses increased again significantly, and the occupation of farrier was again in demand. However, this occupation has taken on a completely new form: the horse does not come to the smithy, but the farrier comes to the horse. Therefore, the farrier takes all the tools and materials he needs to shoe horses, such as horseshoes of

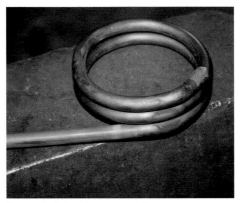

Hot-worked rings bent over a pipe

Finished ring with welding point on the right side

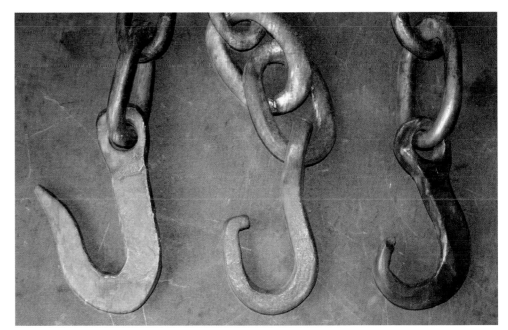

Selection of different old chain hooks. Material defects can be seen in the hook to the right.

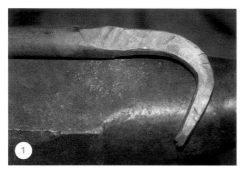

Bending the hook over the anvil horn

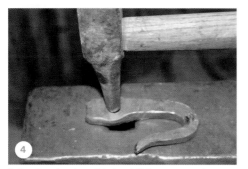

Bending the hook into its final shape

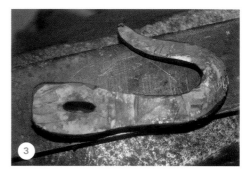

Making a slot for attaching a chain

Enlarging the slot with the drift hammer to the required diameter

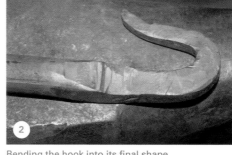

Finished chain hook

various sizes, nails, studs, and other small parts, along with him in his car.

Small, propane-heated gas furnaces are the primary means used to heat the horseshoes.

These furnaces are portable or can be swiveled out from the car; the anvil is set on a portable frame. The farrier stores his hammers and tongs in tool cases in the car.. The horseshoes are purchased in a variety of sizes and designs, with a few exceptions.

The actual forging work is therefore limited to adapting the heated horseshoe to the horse's hoof. The horseshoe is fastened to the horse's hoof by using special horseshoe nails, which are nailed through the hoof and bent over. This requires a lot of skill, since the horseshoe can affect the horse's gait.

From the German occupational name *Huf-schmied* ("hoof-smith") it is easy to conclude that this occupation mainly involves manual forging. The actual forging

work has become limited because the horseshoes are no longer forged by hand. Farriers must, however, be well informed about horse anatomy; they must be able to partially compensate for faults in the horse's gait, and they must also be well versed in how to deal with the horse's hooves and the health of the hooves. Sporting horses usually participate in competitions and are sensitive. To be successful, the horse, rider, and farrier must form a good team.

Making Simple Forged Pieces

In the following section, we provide instructions on how to make simple forged pieces by using the forging techniques described. It certainly is possible to make your way from forging simple workpieces to more-complex workpieces with the help of these basic techniques and depending on your personal skill.

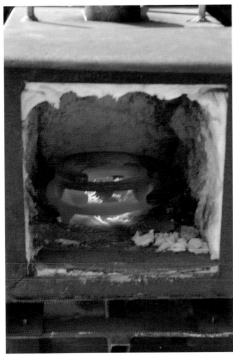

Propane gas furnace for heating horseshoes

Anvil on a support block that can be assembled.

Fine work on a horseshoe

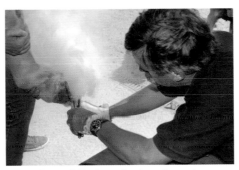

Farrier Gerhard Gissing adjusting a horseshoe

Nails for horseshoeing

We provide measurements only occasionally. These depend on your personal requirements as well as on what possibilities are available, such as obtaining raw materials. Large workpieces require using a power hammer, and often we do not use dies because it requires a great deal of effort to make them.

We describe making these forged pieces, all of which were made by hand, in a loose order. Hammers, an anvil, and forge and fire tongs are therefore sufficient for your basic workshop equipment of the workpiece, which is created by the clamping point.

Simple Basic Elements of an Artistically Forged Scroll

The terms "volute," "scroll," and "spiral" are used differently. There is a clear mathematical description for a spiral, in that the distance of the circular arcs increases outward. The

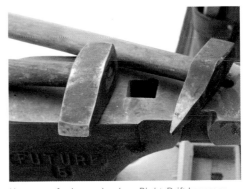

Hammers for horseshoeing. *Right*: Drift hammer with rectangular cross section for punching or widening the holes for the horseshoe nails. *Left*: Asymmetrical grooving hammer for making grooves in the horseshoe

volute is similar in shape to a spiral; both have a round, widening shape, and the space between the circular arcs in a volute can also be constant. Scrolls are understood to be generally used for ornamental bars, which may also contain elements of a volute.

Scrolls are wanted in a wide variety of designs, so it is an advantage to use a bending jig. Flat steel is generally used. Machine-made scrolls are available in different sizes in the trade. These machined scrolls are cold-worked. They are easy to recognize from the straight starting part of the workpiece, which is due to the clamping place.

In artisan manufacture, the flattened flat bars are first spread on both sides, grooved and slightly rolled up, so that you initially get a better hold in the bending device.

A bending jig made from a half scroll is enough for bending scrolls. This makes it possible to make scrolls of different lengths, since the center piece can be of different lengths.

Spirals

Spirals are found in many forged pieces. The following section describes how to make a spiral.

A round steel bar is the starting material for this forged piece. You can also work the piece cold if it has a thin cross section. We are making two spirals of the same size, coiled in a spiral shape.

The two spirals are now pressed out. For this, you can put pieces of pipe with a diameter that corresponds to a specific coil underneath, and press the rings downward with a setting rod until you get the desired spacing. Then bend the two parts by 180 degrees to obtain the desired shape; you can improve the shape further by straightening.

The ends of the two halves may be widened and rolled up more, or you can leave one end as a bar. Spirals are often decorated with leaves.

Balls

Balls are important design elements in forging work. They are often used to make a connecting link between two elements.

The designs vary according to the application—they are available without shank, one-sided with shank, or with shank on both sides. You can distinguish between

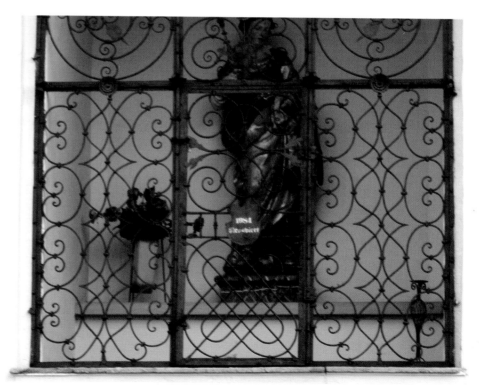

Grating on a chapel in Windischgarsten, Upper Austria, decorated with scrolls

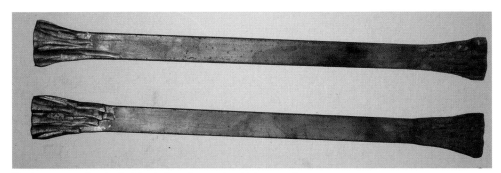

Flat bars grooved on both sides before they are bent into a scroll

Bending half a scroll along a bending jig

Examples of Designs for Scrolls

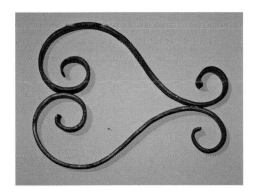

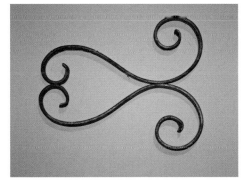

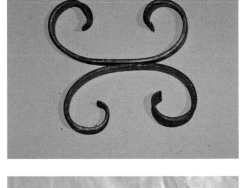

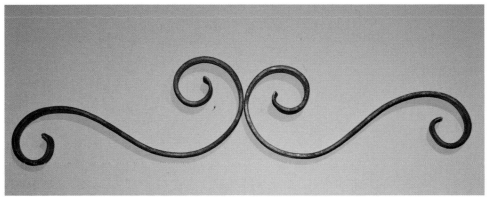

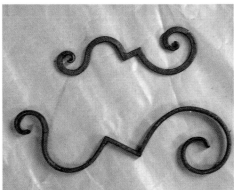

Combinations of different kinds of scrolls

die forging and free-form forging, according to the manufacturing process. In many cases, the ball is preformed by hand and then finally forged in the die.

The illustrated example for making a ball starts out with a round bar. First fuller the shank and then reduce the cross section by stretching.

In this process, you first select a square shape for the shank. The shank is also necessary for safe handling with fire tongs. If necessary, the shank can be cut off after the ball is finished.

After the cross section of the shank has been reduced sufficiently, it is gradually transformed into a polygon and then given a circular shape. The shape of the shank can be refined further using a die, if you have one available.

The cylindrical part is now formed into a ball. First, the cylindrical part is swaged to the point that the diameter equals the cylinder length.

It is not possible to create a completely smooth spherical surface by using free-form forging. Each hammer blow creates two even surfaces: on the bearing surface and the contact surface with the hammer. The surface can be smoothed over by grinding, filing, and sanding. It is easier to work with a die.

For drop forging, it is important that the volume of the part to be forged corresponds well to the volume of the hollow die cavity.

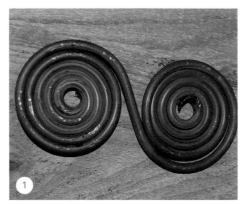

Spiral-shaped coiled steel bar

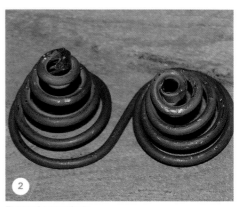

Pressed-out spirals

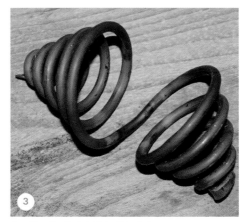

Bending the two halves together

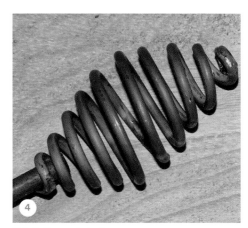

Spiral of round steel

If the volume to be forged is too small, the die cavity will not be completely filled; if the volume is too large, the excess volume must be displaced and will create a burr, which has to be removed. In principle, drop forging takes a great deal of force.

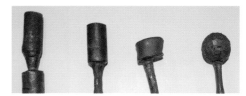

Work steps for forging a ball: fullering and forging the shank, upsetting the cylindrical body for the ball, forging the ball

Rivet Header

Headers are used to form rivet heads. The general shape of a header is a segment of a sphere or lentiform. A whole range of rivet shapes are used for artistic forging, but you cannot make most of these geometric shapes with simple hand tools. The material used is a carbon steel with at least 0.5 percent carbon content. The workpieces are fashioned when they are soft and then are hardened and tempered. If they are available, hot-working steels (such as material number 1.2343 or X37CrMoV 5-1) work very well, since the rivet header surface comes into contact with the red-hot steel. This can prolong the service life of the header.

The header that is described next is simple to make and produces a good result.

This header is made from a round steel bar with a diameter of 0.6 inches (15 mm) and a length of 5.9 inches (150 mm). The steel used has a carbon content of 0.5 percent and thus can be hardened. You can turn the workpiece over on the head side, if it exists. Drill a 0.24-inch-diameter (6 mm) hole in the middle, then use a round file to file two grooves perpendicular to each other, leaving four segments. By pressing the header into plasticine, you can show the surface created by the forging.

The front section of the header is hardened and tempered. With a carbon content of 0.5 percent, it should be heated to about 1,472°F (800°C), corresponding to

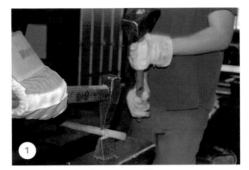

Fullering the shank on a round bar

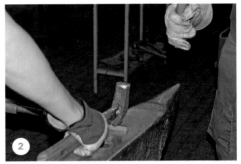

Stretch the shank with a grooving hammer or with the hammer peen.

Die-forged shank of the ball. The volume of the cutoff piece of round bar should correspond to the volume of the finished ball.

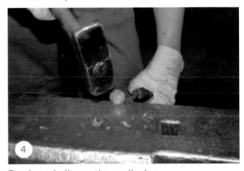

Forging a ball over the anvil edge

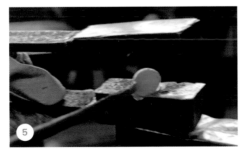

Simple sphere-shaped die. The two die halves are connected with a piece of flat steel, so that the lower and upper die parts join up exactly with each other. The workpiece is shaped either with a hammer on the anvil or with a power hammer.

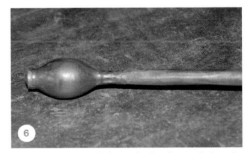

Die-forged spherical shape. In the die used, there is a permanent cylindrical bore with the diameter of the shank. The excess material is pressed into the bore opposite the shank or remains as a burr.

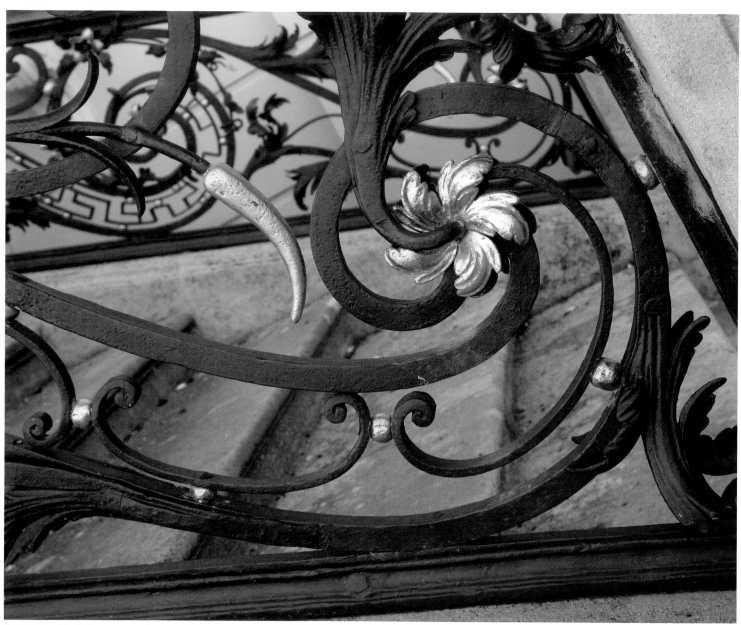

Gold-painted balls form connecting elements on a grating at Esterházy Palace in Fertöd, Hungary.

an annealing color of red heat. To harden this workpiece, it is important that the workpiece is thoroughly and evenly heated, meaning that the workpiece must be brought to hardening temperature throughout its entire cross section. To do this, it is necessary to keep the workpiece at hardening temperature for a long time. Then quench it in a water bath. Since steam bubbles form around the red-hot workpiece, you have to swivel the workpiece around in the water bath.

A workpiece hardened this way has a high degree of hardness, but the elongation is low. Therefore, the workpiece is tempered to about 572°F (300°C), which corresponds to the tempering color blue. Take care to ensure that the entire hardened area is heated to the tempering temperature; otherwise, brittle areas will remain that can lead to fractures later. If you file the workpiece with a finishing file, you will be able to distinguish between the hardened and nonhardened sections. The finishing file will not file into the hardened areas. To be able to better recognize the tempering color, polish the surface bare with a piece of grinding stone.

A gas flame works well for heating the workpiece to tempering temperature. When heating the workpiece over a forge fire, lay the workpiece on the fire so you can control the heating process well. When the tempering temperature is reached, quench the entire workpiece in a water bath.

Volutes

Volutes, called *Schnecken* or "snails" in German, are classic elements of artistic forging. There are no limits to potential designs. In this chapter we provide some suggestions for possible designs and manufacturing methods.

First, sketch the shape of the volute on drawing paper. It is easy to trace the bending design for the volute with soft wire, such as copper wire. If you measured the total length of the wire beforehand, you can determine how long the precut you need should be. You can use the bent wire or the sketch as a template for bending the volute. The advantage of using a wire is that you can hold even red-hot workpieces over it, while paper will easily go up in flames. Using a sample volute as a template also makes it possible to make the volutes the same.

The starting piece for a volute is usually fashioned into the typical volute shape by spreading and grooving, and the volute is then tightly curled up over a mandrel on the anvil.

You can bend thin workpieces over a mandrel on the anvil and over the anvil horn.

For thicker workpieces, you can also use bending forks. Clamp one bending fork into the vise, while guiding the second by hand. Bending forks have a cone-shaped opening, so you can use them to fashion workpieces of varying thickness.

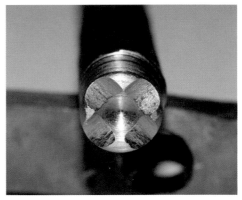
Geometric shape of the header

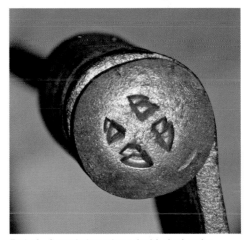
End of a forged piece shaped with the header

Header at hardening temperature

Bending a Volute from a Round Steel Bar—A Sample Volute Serves as a Template

Bending Volutes Using Bending Jigs

If you need several identical volutes, it is worth your while to make a bending jig. You can use bending forks to make the bending jig. The bending jig should be made from flat steel that is thicker than that used for the volute, to make sure there is enough

bending stiffness when you are bending the volute.

A bending jig significantly reduces working time per volute, and the shape of the individual volute is completely similar. If

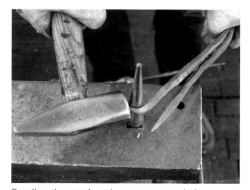

Bending the starting piece over a mandrel

Bending a volute with the aid of bending forks

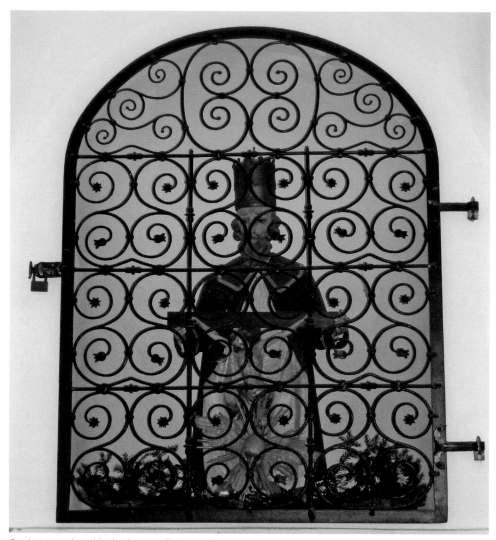

Grating on a chapel in the Austrian Freilicht ("Open Air") Museum in Stübing, Styria

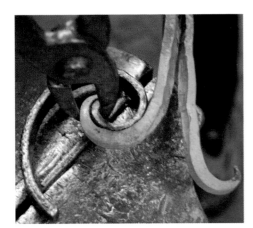

Bending a volute along a bending jig. The starting piece for the volute was bent over a mandrel and is now held in the bending jig with forge tongs. You can use a self-locking pair of pliers instead of the forge tongs. This frees up your pliers hand, which is a big advantage if you are working without a helper.

you use a sketch or a template volute, you will always get small differences.

You can combine the methods for making volutes presented here with other forging techniques. This makes it possible to manufacture complicated workpieces. One of the most frequently used methods is crossing bars by punching and piercing.

Nails and Rivets

Since there is hardly any difference between the methods for making nails and making rivets, to simplify matters we will talk about nails only in the following section. Nails are forged primarily for their ornamental

character. A simple device for striking out nails is used as an additional tool. This is a round or rectangular piece of steel about 1.2–1.6 inches (30–40 mm) thick and a bore with a diameter corresponding to the desired shank diameter for the nail. To demold the nail, it helps if the bore widens conically downward. Since making a conical bore requires special tools, this is rarely possible. It also works to drill a bore about 1 mm larger in the side opposite the nail diameter bore, leaving only a few millimeters of the nail diameter bore.

Work Process
Forge a round bar, with about the diameter of the nail head or slightly smaller, by fullering it to the desired nail diameter and nail length. To get a better, even surface, you can also use a round die. It is a good idea to

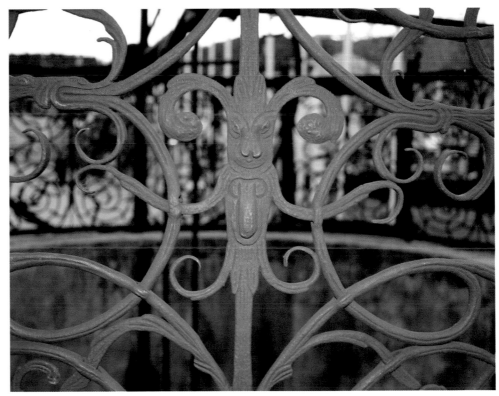

Application of various forging techniques at the "Iron Fountain" in Bruck an der Mur, Styria

make some test pieces to determine how long the section to be fullered has to be, or otherwise your nail lengths can vary by a lot. Now cut off a piece of the round bar; the volume of this undeformed part should correspond to the volume of the nail head. Heat the cutoff part (preform) to forging temperature and then insert the forged side in the mold. Use a forging hammer to fashion the shape of a nail head. Using a nail header, you can also imprint a mark on the nail head. Heat the preform to forging temperature and insert it in the nail tool. Use a hand hammer to swage the cylindrical part and shape the nail head. You must aim the blows exactly, or the head will be off-center on the shank. The nail point is fashioned by grinding in the bench grinder.

Screws with Ornamental Heads

To fasten a forged piece to the wall, you need screws with threads. Here we describe a simple method to make screws with ornamental heads. The method is similar to that for making nails: Cut the head off the screw and weld the threading to a thicker round steel bar. Then, as for making nails, cut off the round steel bar at the place corresponding to the volume of the ornamental head and fashion the ornamental head. It is even easier to take a screw with a large head (such as a hexagonal head wood screw) and forge the head at forging temperature.

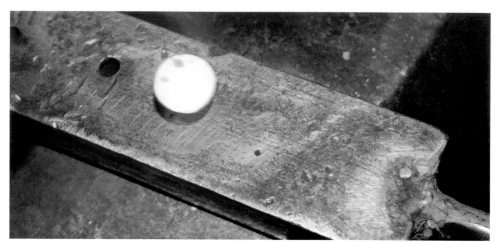

Nail tool made of a rectangular piece of steel, 3.2 × 1.2 × 5.9 inches (80 × 30 × 150 mm). Three bores of three different diameters (4, 6, 8 mm), corresponding to the required thickness for the nail shank, were drilled in the rectangle. We welded on a round steel grip to make it easier to handle the workpiece.

Rivets with Ornamental Heads

Rivets with ornamental heads are made just like nails with ornamental heads. Just omit the point. For safety reasons, forge the shank slightly longer than is necessary and then cut it off to the correct length.

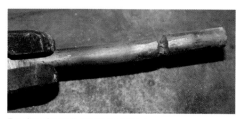

Forging the nail shank by fullering

Handle for an Old Chest Lid

Four square bars were welded to the front to make the middle part of the handle. Draw the bars out in a V shape in the area to be welded, to make room for the welding material. If the welding seam is not deep enough, the welding seam may come open during twisting. Heat the bars to forging temperature and rotate them one to one-and-a-half turns in a vise by using a twisting wrench. If the workpiece is evenly heated,

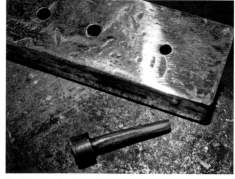

Preform for forging the nail head

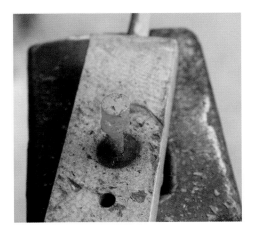

Upsetting the preform

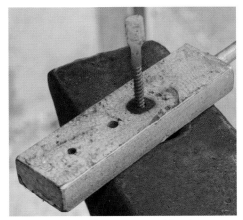

Forging a screw with an ornamental head

(9–9.5 mm) to leave enough play for an M 10 thread, to compensate for any out-of-roundness. Drill 0.24-inch-diameter (6 mm) blind holes into the balls, perpendicular to the ball shank. Solder 0.24-inch-diameter (6 mm) pins into these blind holes.

Drill two 0.4-inch-diameter (10 mm) holes into the chest lid, at center-to-center distance of the two balls, and fasten on the handle by using hexagonal nuts.

Handle with Basket Twist

Basket twists are often used for handles. In the handle shown in the picture, the main element is a basket twist made of square bars welded together at their ends. For this reason, you cannot make this handle from one piece. The two side pieces are welded on.

An alternative method to make a basket twist is to split a square bar on two sides, instead of welding four thinner bars together. This way, the handle can be made from one piece without a welded joint.

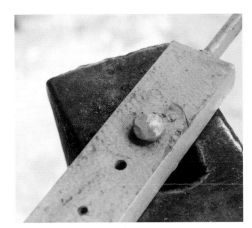

Finished forged nail head

0.24-inch-diameter (6 mm) pins to join the side pieces to the balls. For space reasons, it is a good idea to drill the two holes before welding. Drill only one blind hole, so that the pins cannot be seen on the outside of the side piece.

To attach the handle to the chest cover, make two balls with a shank. The shank diameter was forged to 0.35–0.37 inches

the twisted area will come out exactly centered. Weld two side pieces of flat steel, twisted by a half turn, to the middle piece. Join these two side pieces to the two balls, so that they can turn. Use

Finished triangular-shaped nail head

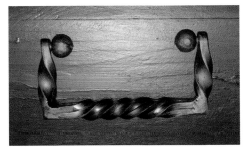

Handle for an old chest

To make the middle piece for the handle, weld four square bars to the front and twist them, when heated, by one-and-a-quarter turns.

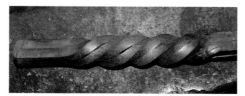

Middle piece of the handle

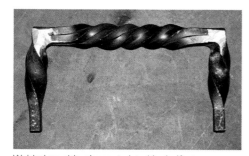

Welded on side pieces, twisted by half a turn

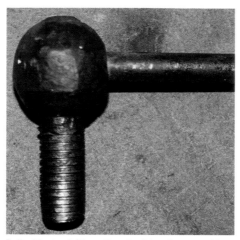

Ball with shank (thread) and soldered-on round bar

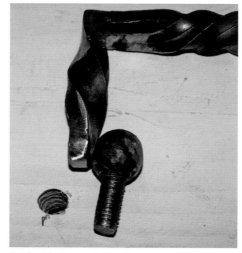

Joining the ball and side piece

sure that *At right*, the end of the handle, drawn to a point and corrugatedthe two square ends are parallel to each other.

The side pieces are also made of square steel bars. The ends for the screw fastening are spread, drawn to a point, and slightly curled.

The side parts are molded to the outer sides. Bend the flat piece at a right angle and cut off the bar. Weld the two sides to the basket twist. Before welding, grind the weld seam area into a V shape so that the welding will penetrate the entire thickness of the workpiece.

After removing any excess welding material, groove the flat surface between the end of the basket twist and the side piece with a grooving hammer. Fasten on the handle with wood screws with ornamental heads.

Handle with a Ball

A ball with a shank on both sides was used to make this handle. Make a ball and shank according to the process described in the section on "Balls." You may have to lengthen a shank by welding on a round steel bar. The

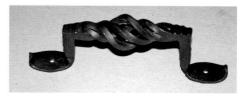

Handle with basket twist

Heat the four welded-together parts evenly to forging temperature and clamp one side into the vise. Use a twisting wrench to twist the bars by about one-and-a-half turns and then twist them back until the basket twist takes the desired shape. Make

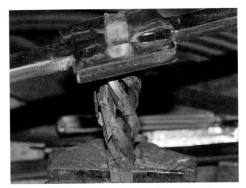

Fashioning the basket twist from four welded-together square bars

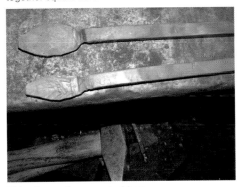

Side pieces of square steel bars

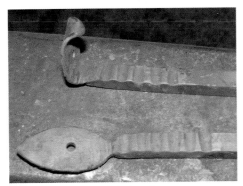

Fullered, spread end of the handle

special feature of this handle is the part for fastening it on.

The section for the screw is spread and formed into a rectangular shape. To make this section, you have to start from a ball.

The corrugated extension of the fastening part is drawn out flat and to a point by forging and bent into the corrugated shape over a tapered stake on the anvil.

The handle is fashioned into the design by bending it 90 degrees twice on both sides. Drill a 0.16-inch-diameter (4 mm) hole into both sides.

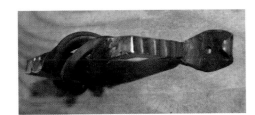

Detail on the handle

Detail of the handle fastening

If you have an appropriate die at hand, you can use a triple ball or a ball with two lateral cylindrical elements.

Such a cylindrical middle piece is often used in different styles for forged pieces. You can also forge such an element with shanks on both sides, even without a die, but it takes a lot of extra effort. To make such a piece, you can braze or weld on the side parts to the handle.

Spreading the area for the fastening screw

At right, the end of the handle, drawn to a point and corrugated

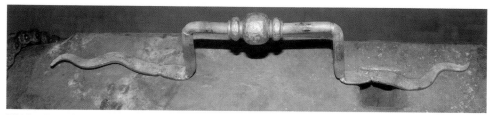

Middle piece of the handle, made in a die

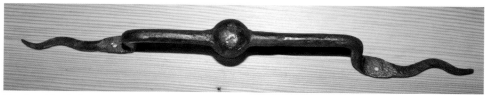

Handle with a ball

Small Candleholder

To make many forged pieces, you also need to work with sheet metal. This is the case for making the small candleholder described below. The piece is made of two pieces of sheet metal: the drip catcher and base, which makes the foot of the candleholder. The drip catcher is made of a sheet-metal blank, 0.06 inches (1.5 mm) thick, which is notched to divide it into ten segments. As shown in the picture, these segments are rounded and embossed in cold work to make them deeper. Use a die to form the center of the blank into a sphere. Drill a hole in the center to hold the point for the candle. The point to hold the candle is forged from a 0.2-inch-diameter (5 mm) round wire.

Forge the ball that forms a connecting piece for the upper section and the base

according to the method described in this book on page 92. The shank remains in place on one side, so it is possible to rivet the ball to the base. You can also leave a small piece of the shank on the side opposite the ball and use it to forge the point to hold the candle.

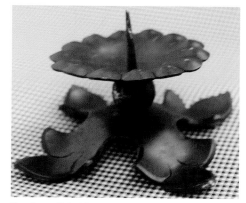

Small candleholder

The base, shaped like four leaves, is fashioned out of a 3.9-by-3.9-inch (100 × 100 mm) piece of sheet metal, 0.08 inches (2 mm) thick, by drilling, sawing, grinding, and filing. Use a template to transfer the outline to the sheet metal. As an alternative, you can use a plasma cutter to cut out the pieces of sheet metal. To do this, the outline must be in digital form. The leaf shape is reinforced by making notches with a chisel with a rounded cutting edge.

Make a hole a few millimeters deep in the ball so you can insert the point in it.

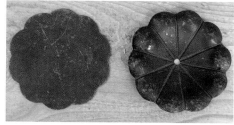

Drip catcher

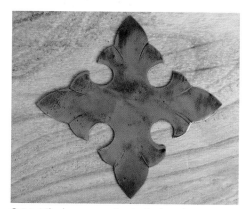

Cut out the base according to the template

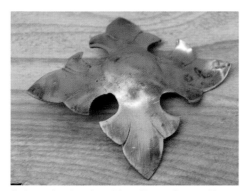

Emboss the piece in cold working or hot working, depending on how thick the sheet is. Use a die to make the workpiece into a sphere. Bend the ends of the leaves over the anvil horn.

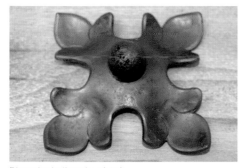

Rivet the ball to the shank.

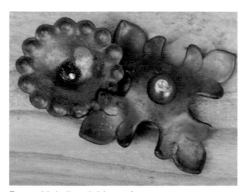

Base with ball and drip catcher

Insert the point and set the drip catcher on top. As a result, the two halves can be brazed without any other joining. It is important that the soldering points are free of scale, so that the solder forms a proper wetting.

Depending on the solder used, a temperature of 1,652°F–1,742°F (900°C–950°C) is required for brazing. The best way to do this is to use an oxyfuel gas flame. You should adjust the flame smoothly; that is, with excess gas. Since the ball has a relatively large mass, it must first be heated more than the drip catcher, so that everything is at the necessary temperature when the solder is applied.

Here, brass solder was used. Flux-coated brazing rods are reasonably priced.

After the brazing process, clean the workpiece with a wire brush. Since the brass solder is visible at the soldering point, the candleholder was painted with black matte lacquer.

Candleholder with Crossed Bars

This candleholder is fashioned out of two crossing square bars. Two 3.2-inch-diameter (80 mm) sheet-metal blanks were shaped into drip catchers.

A hole is punched in the middle of one bar, and the other bar is inserted. The hole is made by slitting with a small slitting punch, and then it is drifted. The first part of the drift is a round cone, and then it changes into a

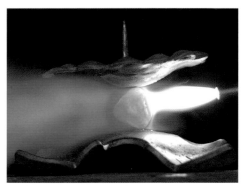

Brazing the upper part to the base

Brazing point. People often find the color of the brass solder unattractive. This can be remedied by painting just that place, or the whole piece.

square shape. The end of the drift should be slightly tapered so it can be driven through easily. The square hole should be dimensioned so that the second bar does not have any play. The two ends are spread and slightly curled. The second bar can be spread and curled on only one side; otherwise you could not insert it.

Due to the position selected for the square hole, the inserted bar has to be twisted by 90 degrees at its end, which serves as a foot.

Now you can also spread the inserted end. The end of this bar is forged flat over a longer section, and two side pieces are split off. You can use a splitting chisel or slitting punch to do this.

Bend out the split side pieces and draw them out in a round shape. Then bend them back and curl them up.

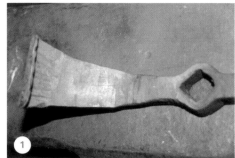

Punched square bar with spread-out ends

One square bar inserted into the other. The feet face upward; the right foot is twisted by 90 degrees.

Splitting the flat forged, punched bar

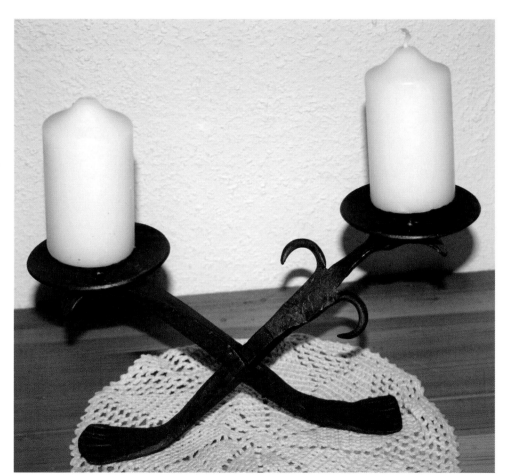

Candleholder with two crossing square bars

Curled side piece

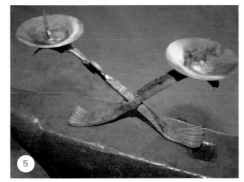

You can check how securely the piece stands on the anvil face.

Next comes the straightening work, especially to ensure that the feet stand firmly.

Make the drip catcher out of two sheet-metal blanks in a spherical die. Make the points to hold the candles out of round wire. File the cylindrical end down about 1 mm thinner. Drill the drip catcher and

candleholders in this diameter. Rivet the points and drip catcher to the candleholder. Instead of riveting, the joint can also be made by brazing.

Candleholder for Wall Mounting or with Stand

With many forged pieces, you can create a very big effect just by making some small changes. The following section describes how to make a candleholder. It can be made with a stand or it can be mounted on the wall.

To make both these candleholders, use a piece of flat steel with the dimensions 1.4 × 0.2 × 20.5 inches (35 × 6 × 520 mm). Splitting, grooving, and bending work are all applied. For the wall-mounted candleholder, you also have to forge a collar. We will not go into making the drip catcher here. Split the flat steel in the middle over a length of 5.9 inches (150 mm). Split the two halves again, draw them out to a point at the ends, and bend them over a bending jig into a volute. Since this volute shape is used several times, it is worthwhile to make a bending jig for the volute. Clamp the bending jig into a vise.

For the second design variant, forge the nonsplit end into a cone shape and curve it inward.

To hold the drip catcher, use a collar to attach the spread and curved piece of round steel to the end.

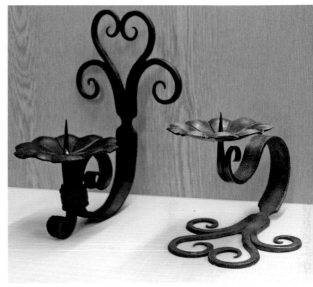

Examples of possible designs for a candleholder

Forging Leaves

Leaves are a frequently used design in artistic forging. Copper and brass are used, in addition to iron and steel.

There are basically two usual methods for making leaves: forging from a bar or cutting it out of sheet metal and embossing and bending. In both cases, fuller a shank as the leaf stalk and forge the remaining wide piece into a leaf shape. When the round steel is spread, it inevitably creates a rectangular shape. If the round part is fashioned into a ball or pointed ball, this creates beautiful leaves.

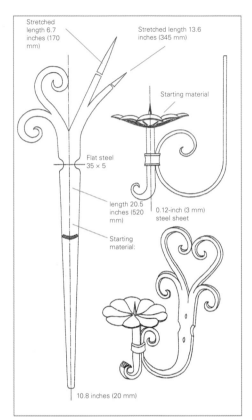

Design for the wall-mounted candleholder shown in the picture (specialist head teacher Walter Pichler, Höhere Technische Bundeslehranstalt Kapfenberg).

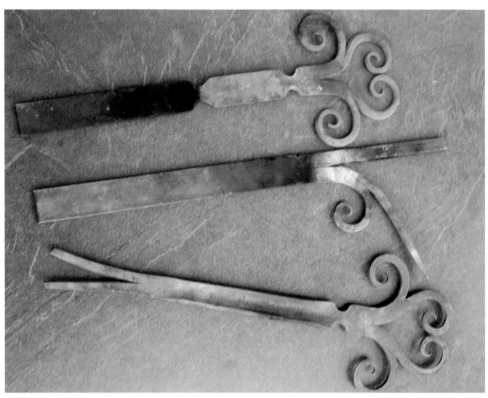

Different versions of candleholders. *Center*: Splitting, drawing out to a point, and bending the flat steel—this part is the same for both versions. *Top*: Part for wall mounting. *Bottom*: Part for a freestanding candleholder. In this part, the middle piece is grooved and the end piece is also split. Half of it is bent into a volute and the second half is forged to a point to hold the drip catcher and the candle.

Bending the volute by using a bending jig (bending template)

Grooving with a simple device. This creates a clear demarcation . . .

. . . between the volute and the rest of the piece. Finished grooved flat steel piece

Element for holding the drip catcher of the wall-mounted candleholder

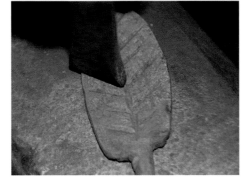

Shaping the grooves in the leaves with a grooving chisel

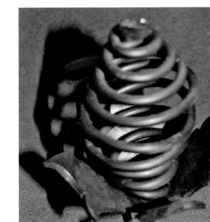

Leaves on a "spiral"

Four-Blade Leaf of Sheet Metal

This piece of sheet metal, 0.06 inches (1.5 mm) thick, is drilled, sawed, ground, and filed into the right shape. Use a scriber to transfer the geometric design to the metal. The roundings on the individual leaves were created by bending and embossing. If possible, you could also use a computerized plasma- or laser-cutting system to cut the metal.

Forging a leaf from flat steel and round steel. The leaf stalk is fullered and the wide piece is forged into the shape of a leaf by spreading.

Bracket for a Rain Gauge

Rain gauges are popular for use in house gardens. Typically, the containers are held by a plastic ring hung on a stick. With a little effort, you can create a more beautifully shaped holder.

This consists of a round 0.4-inch-diameter (10 mm) steel bar, an elongated leaf with stem, a receptacle for the rain container, three curved scrolls, and a collar.

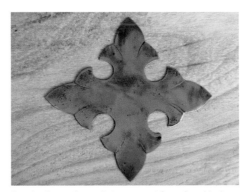

Punched-out piece of sheet metal for a four-blade leaf

The bar for the rain gauge holder is split in the center of its upper end and curved over the anvil horn. Weld on an elongated leaf, also made from a round bar, in the middle.

Use a 0.3-inch-diameter (8 mm) round bar to hold the rain container. Draw the bar out to a point and twist it into a spiral shape. Then bend the round bar over a pipe held in a vise to the required diameter, angle it 90 degrees, and fashion the end into a scroll. Fasten the holder, along with the three remaining scrolls, to the stand at small welding points. Finally, attach a collar to hold the piece together.

Shape and twist the stand in one piece into a square cross section between the scrolls and the tip. The length of this twisted piece is about a third of the length from the

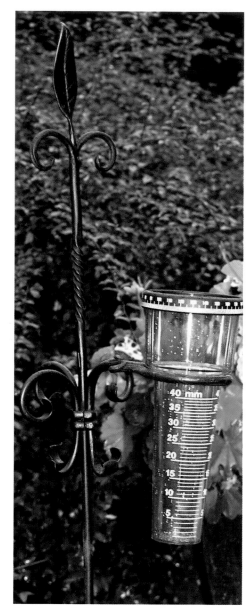

Container to find the amount of rain per square meter (rain gauge)

Top end of the rain gauge holder

Decorative elements with holder for the rain gauge

Design of the end of the ring-shaped container holder

scrolls to the tip. The lower end of the stand is forged to a point so that it is easy to push the stand into the ground.

Flower Design Made of a Spiral and Four Leaves

You can find different versions of this design on gratings. To make it, join a spiral made from a 0.2-inch-diameter (5 mm) round bar to four leaves made of sheet metal. We described how to make a spiral in a previous section (p. 92). The four leaves were also used for a candleholder. For the candleholder, the leaves were made by hand; for the above-described flower design, they were machined from 0.08-inch (2 mm) sheet metal by plasma cutting.

Form the piece of sheet metal into a slightly spherical shape in a half-round die. The tips of the leaves are bent outward over the horn of a small anvil.

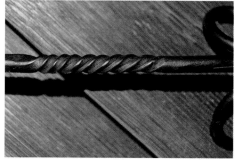

Twisted area between scrolls and tip of the rain gauge

Join the spiral and leaves by brazing and solder a round bar to the middle. To do this, bore a hole where the round bar is inserted in the middle of the leaf part. Brush or file clean the areas to be soldered, so that the solder binds.

Simple Floral Element

The flower element shown here is made of a piece of sheet metal 0.06 inches (1.5 mm) thick, a ball, and a round bar.

Divide a 3.2-inch- diameter (80 mm) sheet-metal blank into fourteen segments and make the segments round in shape, as shown in the picture. If possible, you can use a plasma jet or laser cutter to cut the sheet-metal blank. You have to digitize the geometry to do this. Notch the segments to a length of 0.6 inches (15 mm) from outside,

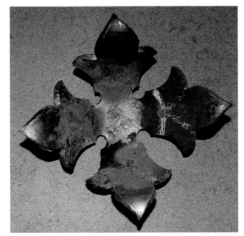
Finished bent sheet metal with four leaves

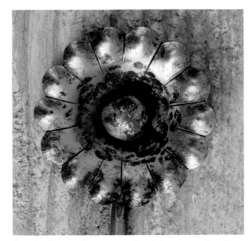
Simple flower element made of sheet metal and a ball

using a rounded grooving chisel. Drill a hole in the middle of the blank for a center.

Shape the individual segments into spherical form by using an embossing hammer. Next, shape the inside into spherical form, like a dish.

The ball is designed with a shank on one side. Enlarge the hole in the center of the sheet-metal dish to the diameter of the shank. Cut off the shank on the ball so that the shank still protrudes on the rear side of the metal sheet by approximately the length of the shank diameter. This makes it possible to rivet the ball and sheet together. You can solder on or weld on a round bar to attach the flower element.

Nail Puller

This section describes how to make a nail puller. Use this woodworking tool to extract

bent nails or take down nailed-on pieces of wood.

The nail puller is forged from a 0.6-inch-diameter (15 mm) round steel bard. At the point of force application on the nail head, the cross section of the nail puller must be as small as possible, so it can grip nail heads that protrude only a little bit. For this reason, use a hardenable steel, such as C 45, a car-

Flower design made of a spiral and four leaves

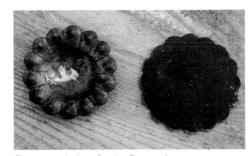
Sheet-metal piece for the flower element

bon steel with 0.45 percent carbon content. The hardening temperature for this steel is 1,544°F (840°C), and the tempering temperature is 1,112°F/600°C (manufacturer's specification).

The ratio of the lengths A to B, which yields the leverage ratio, is important for how the nail puller works. The main work to be done: spreading on the side where the nail is gripped, splitting the center, and setting the area that is to grip on the nail head. After splitting, align this area and shape it to grip on to the nail head with a blacksmith's fuller hammer or fuller chisel.

The split and fullered part of the nail cutter still must be mechanically processed by grinding or filing. Further work includes bending a right angle, which should be as well rounded as possible. The hand area can still be slightly angled, but this is of no importance for how the tool works.

Window Grating with Scrolls

Gratings and frames for them are forged work frequently in demand. In this section,

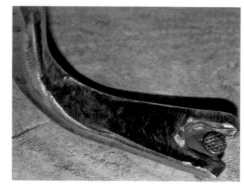

Geometric shape of the nail puller

we describe how to make a small window grating made from round bars.

This small window grating is made of four elements: four bent main elements, spread at the ends, four points, four collars, and four brackets to attach it to the window frame. If you like, you can also attach this grating element to a large grating. For better handling when making the collars, the individual elements are fixed with small welding points.

In this piece, the collar is also a design element. To attach the grating to the window

Fullered area for gripping the nail. The wedge-shaped gap makes it possible to draw nails of different thicknesses.

frame, forge U-shaped hooks with points, which are hammered into the window frame.

Clothes Hook

Clothes hooks usually make popular forged pieces for beginners. To make the workpiece shown, line up three balls together. This arrangement, with a larger ball in the middle, is often found in other forged pieces, such as handles. If you have one, use a die to forge this unit out of three balls, and weld or braze a round bar to each end. If this is not possible, you can make the balls individually and then weld them together.

To make the clothes hook, weld round bars for the hat holder and the actual clothes hook on both sides. Taper the two round bars toward the end; the end for the hat holder is spread and curled.

To mount the forged piece on the wall, here we selected a nail with an ornamental

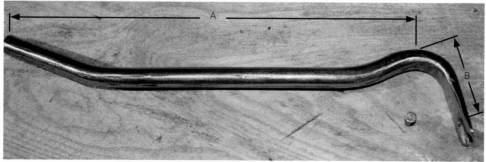

Forged nail puller

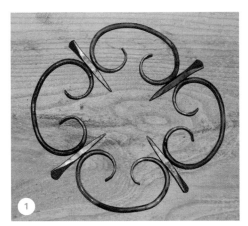

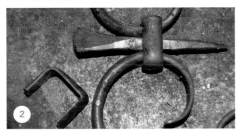

Single elements of the grating. The points are made from round rods.

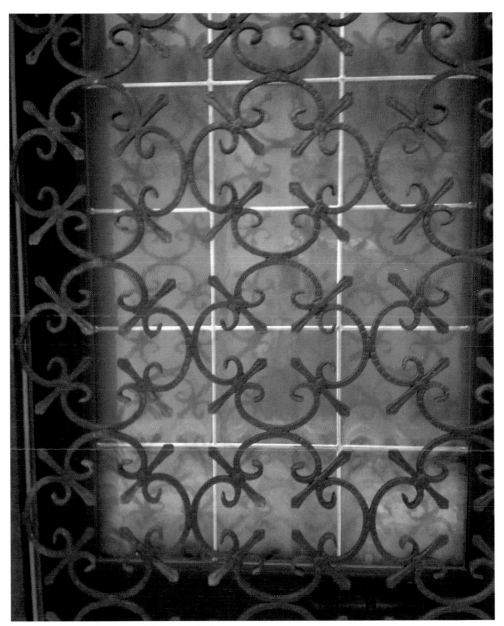

Prebent and ready-mounted collar

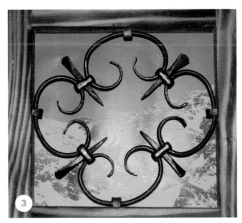

Small window grating made of round bars

Large window grating made of the same single elements

head. To do this, drift the bar and forge a counterbore with a ball hammer.

The second side is also tapered toward the end and bent into a semicircle over the anvil horn. Swage the end of the bar so that a small head, similar to a nail, is formed.

To mount the clothes hook on the wall, you can also use a decorated crimped sheet. This crimped sheet gives you a wide scope for design. In the piece shown, the sheet was hammered.

To prevent the hook from slipping off or twisting on the mounting plate, you still have to fasten it by brazing or welding.

Basket Twist

A "basket twist" is a specialty made by twisting. This is manufactured by simultaneously twisting at least two bars or a single bar split at least once. In the simplest way of making a basket twist, the bars are welded together at their ends. The workpiece, heated to forging temperature, is clamped on one side and twisted at the other end and partially turned back again, while being compressed at the same time. In the somewhat more elaborate method, the bar is split once or twice and then bulged out. In this process, it is necessary to align the individual split sections so that all the parts bulge outward in the same shape. Then twist the workpiece until the desired shape is reached.

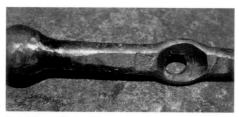
Detail for wall mounting

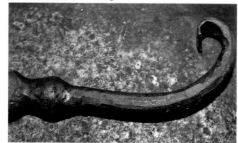
Hat holder

Swaged semicircle-shaped detail

Clothes hook with simple mounting with an ornamental nail or ornamental screw

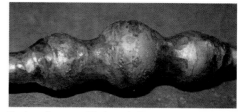
Design element with three balls

Mounting-plate version of crimped flat steel

Fastening the mounting plate to the hook by brazing

A different way to mount the clothes hook

Making a Basket Twist by Machine

Special machines are used to make larger numbers of basket twists by machine in cold working. To use these machines, clamp the blank—welded from four bars—into the machine. On the control panel, you can set how many revolutions the bar will be twisted and how far it will be twisted back, to create the desired basket twist shape.

Window Grating

This type of grating is often found in various designs. Two crossed bars are held together by an element. There are many ways to install it in a window frame or a frame.

If you let the round bars protrude outside the wood of the window frame, it secures the grating against being pulled out of the window frame.

Method

The heated flat steel is bent into a circle by using a disk. It is a good idea to allow extra beyond the length of the flat steel. Bend over the beginning and end of the bar so they overlap and cut off at the cutting point with an angle grinder. Bend the two ends together and sand them on both sides at a slant, so that the entire cross section is melted and welded during welding. Excess welding material is removed by sanding and filing.

For setting the four points for the punch holes, draw the right-angled coordinate axes

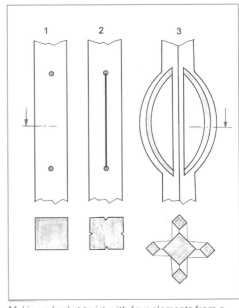

Making a basket twist with four elements from a square bar by the splitting method: Mark the length of the section to be split with a punch (*1*). Since marks made with a scriber are not visible on red-hot metal, when the metal is cold, use a chisel to make grooves to mark the sections to be split (*2*). These grooves are also visible when the metal is red hot, so you can guide the splitting hammer exactly down the middle. Then heat the workpiece to forging temperature and do the splitting process. Use a chisel to bend and align the split sections (*3*). Splitting will not create elements that are exactly square shaped, so further work is required.

and a circle with the outer diameter of the circular ring on graph paper. Use a right angle and a scriber to score in the places for the punch holes. In principle, you can also make the punches before bending, but it may happen that you cannot exactly maintain

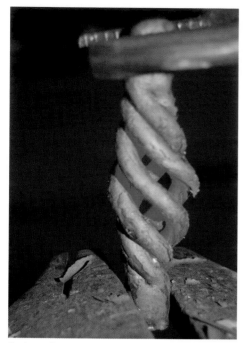

Basket twist made of five round bars welded together. First twist it for one or two turns and then twist it back partially, while pressing down. The downward pressure can affect the diameter of the basket twist. Scale is falling off the outer layers, which are already cooling down.

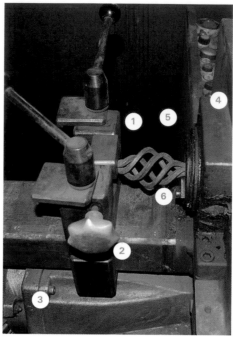

Machine for twisting, bending, and embossing in cold working. Fixed clamping device for torsion bars and basket twist, axially adjustable (1), tension screw (2), engine-gear unit (3), control and adjustment panel (4), finished basket twist (5), rotating clamping device (6).

holes were made in the right position, it will be easy to insert the second bar through the circular ring and the round bar. This fixes the circular ring so it won't move, without any welded or soldered joint.

Now finish the grating mechanically with a wire brush and file, and it can be installed in a window frame. If you let the straight bars protrude beyond the window frame, this fixes it into in the masonry, and it cannot be pulled out.

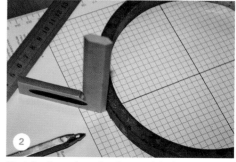

Bending a piece of flat steel with an 0.7-by-0.4-inch (18 × 10 mm) cross section over a disk

Mark the four places for the punch holes.

the spacing between the holes, so that the bars would not be perpendicular to one another.

Split the marked places down the center with a small splitting hammer. Use the drift hammer to widen these points to the required diameter.

Install two bars, crossed at right angles to each other, within this circular ring.

Punch one bar and insert the second bar through this hole. The bar must be punched when it is already installed, since you cannot install the workpiece when it has already been enlarged. To make the punch, put a square block under the bar at the point to be split, to save straightening work. Spread the area to be punched slightly, so that it is easier to center the splitting hammer. After punching, the round bar and circular ring are joined inseparably.

Twist the punched round bar 90 degrees and insert the second bar through. If the

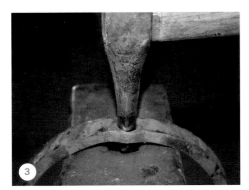

Punching a hole with a punch hammer

Rectangular crossed bars

Brackets

The following sections describe how to make brackets. This kind of bracket can be used, for example, to hold flower boxes on a wall. The two spirals serve as supports for the right-angled bracket.

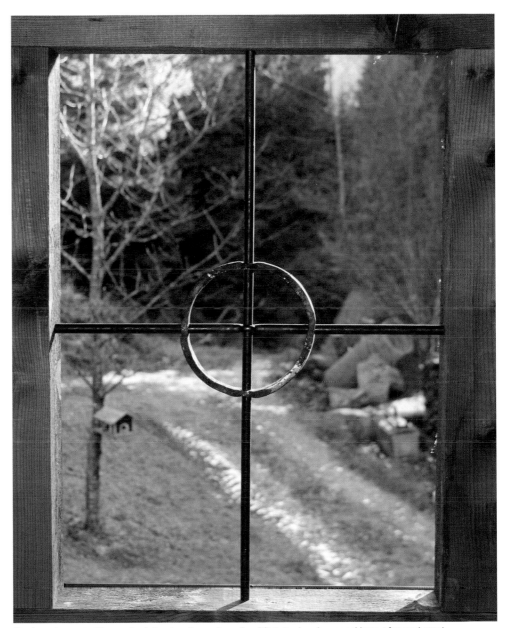

Grating element with punched circular element made of flat steel and crossed bars of round steel

Marking the places to be punched. Place a square block underneath.

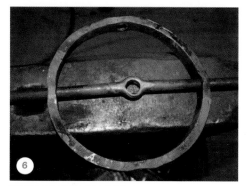

Finished punched round bar

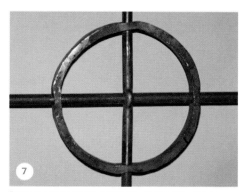

Push the second bar through, so the circular ring can't move.

Bracket 1

First bend two volutes of 1.0-by-0.2-inch (25 × 5 mm) flat steel over a bending jig. Then weld these at the ends, as shown in the picture. Take care to ensure that the welding points are completely welded through. Grind off any excess welding material and draw out the welded place to a point.

For the right-angled bracket, spread, groove, and round two pieces of flat steel at one end. Weld the two pieces at a right angle and grind them smooth.

For visual reasons, the two flat steel pieces should have a slightly larger cross section than the flat steel for the spirals.

There are several possible ways to join the brackets and spirals, such as riveting, soldering, or welding.

Here we used balls as spacers between the spirals and brackets, to improve the visual effect. To attach the balls, two 0.3-inch-diameter (8 mm) holes were drilled in the bracket, and the holes were countersunk on both sides. This makes it possible to attach

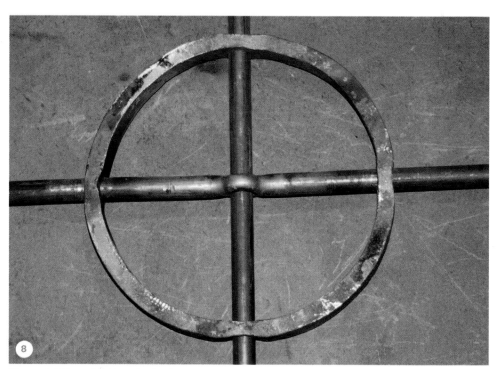

Two crossed bars, held in a circular ring

the balls securely. On the back, the balls are welded level through the bore and counterbore. Solder the two spirals to the two balls by brazing.

Make two holes in one arm of the bracket to fasten it to a wall, then hang it by using screws with ornamental heads.

Bracket 2
You can make the bracket described below with relatively little effort. It can be used to mount flower boxes on windows.

Make the bracket out of 0.8-by-0.16-inch (20 × 4 mm) flat steel. First bend the two volutes and weld them together **as shown in the picture**. Remove any excess material

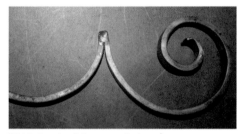
Welded ends of the two spirals

by grinding with an angle grinder or by filing. You could also make two volutes from one piece, but it is easier to make the sharp-edged bends by welding than by bending.

Shape the two flat bars for the right angle differently at their ends. The upper part is spread, grooved, and bent upward in a vise, so that the flower box cannot slide out. Since the cross section of the flat steel is relatively narrow and you should heat the narrowest area possible—just the bending point—use an oxyfuel gas flame to heat the workpiece.

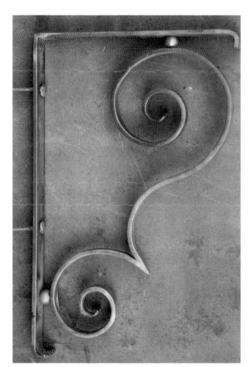
Bracket of flat steel. Fasten it to the wall with screws with ornamental heads.

Drawn-out pointed ends of the two spirals

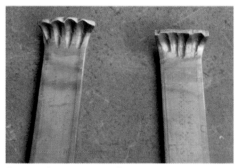
Grooved flat steel pieces for the right-angled bracket

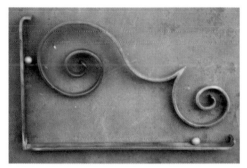
Single elements for the bracket

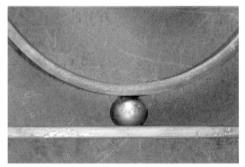
Joining the spirals to the bracket with a ball as a spacer piece

Fastening the bracket with screws with ornamental heads

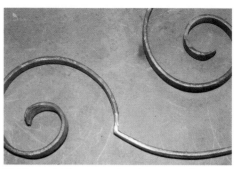

Welding point for connecting the two scrolls

(0.16 inches or 4 mm) + length of the round piece (0.6 inches or 15 mm) + thickness of the angle (0.16 inches or 4 mm) + extra (1.5 × 0.24 inches [6 mm] = 0.35 inches [9 mm]) = 1.26 inches (32 mm).

On the visible side, make the rivet joint with a visible ornamental head; on the back side, use a countersunk rivet. To do this, countersink the bore with a counterbore or a larger spiral drill.

Fuller and round the vertical end of the bracket and draw it out to a point.

The two flat bars are likewise welded at right angles. To join the volutes, we selected a rivet joint with two round pieces between angle and volute. The two round pieces do not have any special function; they are just to improve the overall impression of the workpiece.

The rivet heads were made out of 0.24-inch-diameter (6 mm) round steel by swaging, similar to the way to make an ornamental nail. The round pieces, 0.6 inches (15 mm) long, are cut from a round bar with an abrasive cutting machine and bored. Drill all the bores with an extra 0.5 mm for a 0.25-inch (6.5 mm) diameter. We determined the length of the rivet by using the total length of the parts to be joined, plus 1.5 times the rivet diameter as extra. This yields the following: thickness of the volute

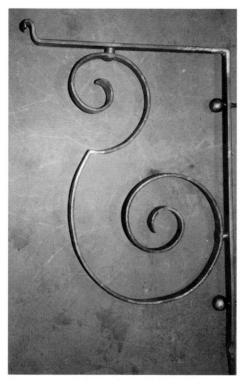

Bracket made of flat steel to hold flower boxes

Upper end of the bracket

Use screws with a spherical head to fasten the bracket to the wall. The balls are drilled and a screw shank is brazed on.

Straighten the finished bracket, if necessary, and clean it with a wire brush. Then paint the bracket with a base coat and then a metal paint.

Bracket 3
Several forging techniques were used to make the bracket **shown here**. Flat steel was used to make the angle, round steel was used for the volutes and the connecting

piece between the two volutes, and half rounds were used for the collar.

Two flat steel bars were welded together to make the right-angled flat steel section. It is also possible to fashion the angle from one piece by bending it at a right angle. It is easier to create a sharp-edged angle by using the welding process.

Vertical end of the bracket

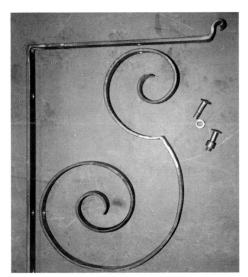

Preparation for riveting to join the angle with the volutes

The two ends are spread, grooved, and curled. The vertical angle is bent by 90 degrees and shaped into a quarter-circle arc on the back of a vise. For the wall mounting, drill two holes and one hole for the rivet joint with the volute. Bend the horizontal angle piece likewise at a right angle and drill a hole for the rivet joint.

A 0.4-inch-diameter (10 mm) round steel bar is bent to make the two volutes. Use a bending jig to do this. Draw the round steel bar out to a point over a 3.9-inch (100 mm) length and prebend it over a sharpening device (filing block) on the anvil. Then hold the round steel bar with a pair of pliers at

Preparing the rivet joint

Rivet head and fastening screw with ball head

the beginning of the volute and bend the first part of the volute. You will need to do several heatings (heats) to bend the entire volute.

Cut the volutes to the same length. Draw the end out to a short point and curl it slightly. Insert an intermediate piece between the volutes.

This intermediate piece is made from a round steel bar. Fuller in a shank and fashion a ball on one side. Spread and split the second end, and forge the two split halves into a round shape. Bend the two halves into a round shape with the extra length, then bend the extra length back, as shown in the picture.

Join the volute and intermediate piece together with a collar. To make the collar, it helps to fasten all three parts together first with a small welding point.

We selected the riveting method to join the volutes to the angle. Alternative methods would be welding, brazing, or screwing.

We used a rivet head on the visible side, and a countersunk rivet for the angle. This means that nothing protrudes into the mounting side and the holder side.

Use screws with a spherical head to fasten the bracket to the wall. Drill a blind hole into the balls and braze in a headless screw.

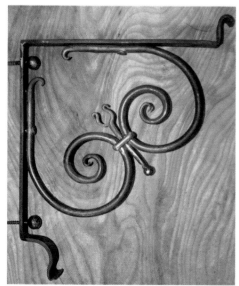

Bracket with volutes, rivet joint, splitting, collar, balls, and bending, spreading, and curling work. The angle was fashioned with a welded joint.

Door Hinge

Forged door hinges are also among the classic forged pieces of the past. Door hinges are cold-worked and machined to optimize costs. Hand-forged door hinges are used only in special places. We will describe how to make a hand-forged door hinge in the following section.

Use flat steel with a cross section of 2.0 × 0.24 inches (50 × 6 mm) as the material. The length depends on the width of the door.

Draw the positions for the splits true to scale on a piece of cardboard, cut it out, and

transfer it to the flat steel bar. Mark the most-important positions, such as the beginning and end of the splits and the split width, with a flat chisel, so that you can see these points when the steel is red hot. After heating to forging temperature, do the splitting work on the anvil, using a splitting hammer and sledgehammer. To protect the hammer and anvil, place sheet metal between the anvil and the workpiece.

Bend the split parts 90 degrees to the side and draw them out to a point. Next bend them back and then bend into a circular shape over the anvil horn.

End of the vertical angle. The end was spread and curled; the round part was formed over the back of a vise.

Horizontal end of the angle

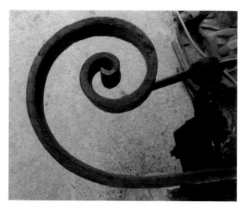

Bending jig for bending the volutes

Volutes made of round steel bars

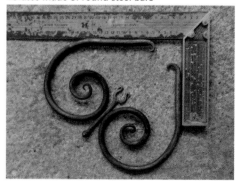

Align the elements before joining them

Intermediate piece with small ball. The shank is split, forged round, and bent.

Joining the two volutes with a collar and an intermediate piece

Riveted join of volutes and angle

Use this method for splitting and bending twice in the same way. Do another splitting and curling process at the same width but make it substantially longer. Since burrs are left by the splitting and unevenness occurs, rework these mechanically. You should also remove any remnants of loose scale and soot by using grinders and sanding disks.

The next work step is to bend the round sleeve to hold the door hinge pintle. This is done using a round bar, which is inserted into the square anvil hardy hole. Since the bending is done at forging temperature, you do not have to reckon with any springback, as when bending in cold working. The mandrel used for bending should have the same diameter as the door hinge pintle. Bending creates of necessity a small play in the diameter, which is slightly reduced by cooling.

For the last step, drill the holes to mount the door hinge. You can also punch these, as was usually done historically. This takes a disproportionately larger amount of effort and doesn't create any advantages.

(Gate) Door Hinge Pintle

This is made to match the described door hinge. The door hinge pintle is made in two parts. A 0.8-inch-diameter (20 mm) round steel bar, corresponding to the door hinge diameter, is given a support or hinge pad.

The pintle is mounted on a bracket, which is hammered into the door frame. A supporting hinge pad is on the underside of the pintle. There are many ways to design this hinge pad. **Here**, the lower part of the pad was spread and drawn out to a point. The spread section is rounded on the vise back, and the pointed end is curled.

The spread section of the hinge pad is arched inward and the pointed end is slightly curled. The circular part of the door hinge pintle is split off longer than necessary, which leaves a bearing point for the three-jaw chuck of a lathe, and you can turn the section for the door hinge to the required diameter. This also makes a stop for the bracket. After turning, cut off the bearing point with a circular saw.

Door hinge with six splits

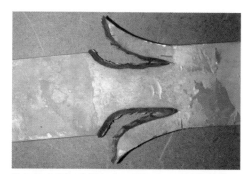

Flat steel, 2.0 × 0.24 inches (50 × 6 mm), with splits

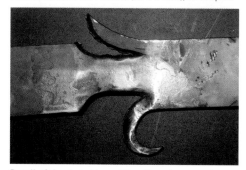

Detail of the door hinge. File off any burrs and small unevenness, then sand the workpiece with a sanding disk.

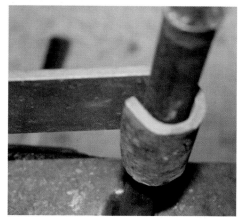

Bending the flat steel over a round bar

Sleeve to hold the door hinge pintle

We likewise used a 0.8-inch-diameter (20 mm) round steel bar for the bracket. One side is forged slightly flat to hold the door hinge, to obtain a larger mounting area for the door hinge. This flat area is punched, first with a punch chisel and then with a punch hammer. Forge the second side out to a point so that the bracket can be hammered into the door frame. When hammering the pintle to the wall, it helps to have a flat surface on the side of the hole.

After punching, cut off the round steel with an angle grinder. Choose the length for the round piece so that the bracket is long enough after you have drawn it out. Use the anvil horn to spread the workpiece while drawing it out to a point.

The hole diameter on the bracket is about 1 mm smaller than that of the door pintle. Hammer the heated bracket on to the pintle by using a pipe; it shrinks on to the pintle as it cools. This creates a permanent, play-free mounting between the bracket and the door hinge pintle.

Wall Cross with Split Forged Design
Split Forging Cross Example

Crosses are a frequent design for blacksmith work. Making them provides an opportunity to set no limits to your creativity. You can get ideas from churches and in cemeteries. In some cemeteries, especially in Austria's Alpine region, you will almost exclusively

Door pintle with door hinge in mounted position

Spread and pointed end of the door pintle (hinge pad section)

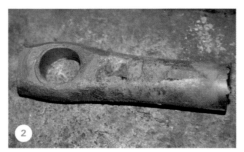

Punching the bracket. Since the square hardy hole in the anvil was too big at first, we used a support with a smaller hole.

Separated bracket piece

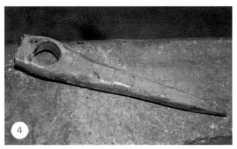

Bracket drawn out to a point

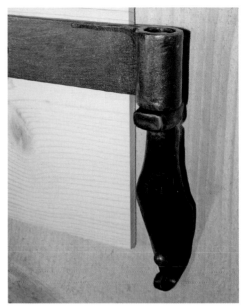

The finished assembled door hinge and door pintle. Use a nail with ball head to fasten on the hinge pad.

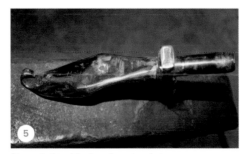

Door pintle with shrunk-on bracket

find forged burial crosses, both in traditional design and in modern form.

In the following section, we describe how to make a simple wall cross, using elementary forging techniques.

The following **work techniques** are used:

• Cutting off
• Marking
• Splitting
• Bending
• Crimping
• Riveting

To make the wall cross shown in the picture, we used flat steel with a cross section of 1.2 × 0.2 inches (30 × 5 mm). The long piece is 15.7 inches (400 mm) long and the crosspiece is 10.2 inches (260 mm) long.

Split the ends of the two bars over a length of 1.6 inches (40 mm); we selected 0.35 inches (9 mm) for the width of the side part, yielding a width of 0.47 inches (12 mm) for the middle piece. Notch in the beginning and end of the split section, using a chisel in cold work, so that the marks can be easily seen even when the workpiece is red hot. You can do the splitting work with a hand chisel or a splitting hammer on the anvil. Put a piece of sheet metal under the sections to be split, so that the cutting edge of the splitting tool does not strike the hard anvil surface and become dull. Draw the two sides out to a point. To do this, they must be

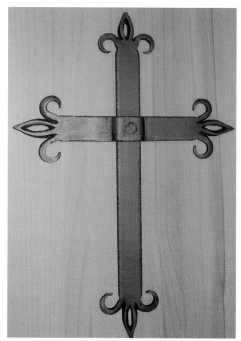

Finished wall cross

We selected crimping and riveting to join the two cross halves. We made a makeshift device for the crimping. Two rectangular pieces of steel were welded at the crimp interval to a cube of metal. These pieces are welded only on the front sides, so they can be removed relatively easily and reattached in another position. The minimum distance is given by the width of the flat steel and twice the flat steel thickness. For better handling, a pipe was welded to the cube as a shaft. The center of the cross section to be crimped was marked with a heavy punch.

It is a good idea to also process the forged parts mechanically. Use sanding disks to remove burrs and any dirt adhering to the workpiece. You can remove any small inaccuracies due to forging with a file.

Forge a rivet with a 0.24-inch (6 mm) shank diameter and a slightly domed head for the riveting. To do this, indent a round bar

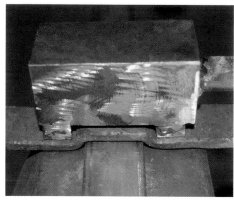

Crimping the cross bar

Join the two halves of the cross by crimping and riveting. The work with the hammer peen can be seen on the sides.

bent away for the forging work. The center piece is sharpened at the end. Then bend the side pieces straight again and split the center piece. You can enlarge the split by using a mandrel or splitting hammer, as shown in the picture.

Then bend the side parts into the desired shape over a mandrel. To give the straight flat steel pieces more visual interest, the sides of the two parts are worked using the peen of a bench hammer. This can be done in cold work, which creates a visual improvement with little effort.

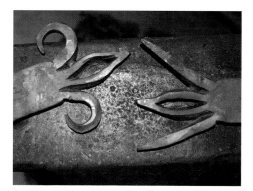

Splitting and bending work on the ends of the cross

and forge it to the shank diameter. The thicker end is cut off, swaged, and fashioned into the desired shape. Drill into the two crosspieces so that the sideways side length and the upper side length are the same. The hole is recessed on the back to obtain a flush surface when riveting. Shape the rivet head with a header with top relief in hot work.

Clean the cross thoroughly with a wire brush and paint it a matte dark gray.

Bottle Opener

Bottle openers for bottles with crown corks are mainly made as pressed metal. It is unusual to make such a bottle opener by free-form forging from a solid piece. We start with a flat steel piece with a cross section of 1.2 × 0.2 inches (30 × 5 mm). Fuller the flat steel in the area of the opening with a fuller hammer and drift the opening. To do this, forge a cone-shaped drift punch with the dimensions of the opening you need for the crown cork, and file it as smooth as possible to keep the resistance low when it is struck.

To enlarge the hole, you will need repeated heats. When the hole has reached the required size and the outer contour is adjusted, use another fuller process to fuller a small area on the handle side to a thickness of about 1 mm. This part grips onto the crown cork to lift it off the bottle.

There are many ways to design the handle. In the example shown, the flat steel was tapered over its width and rounded with the hammer peen. We deliberately did not smooth out the impressions made by the hammer strikes. This created a more interesting inward-curving surface.

Garden Stand with Volutes

This forged piece includes several basic forging techniques. These include volutes, scrolls, collar, and spirals.

Fullered and prepunched flat steel piece for the bottle opener

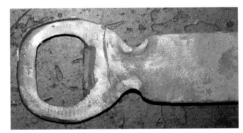

Fullered section on the right side of the hole. The transition from opener to handle has rounded notches.

The garden volute is made from a flat bar with a cross section of 0.8 × 0.4 inches (20 × 10 mm). We have described how to make the individual elements in the preceding chapters.

The two volutes are made from a 0.4-inch-diameter (10 mm) round steel bar.

The two ends are drawn to a point. As an alternative, the ends can also be spread. The lower end of the spiral is only slightly curled. The pieces are attached to the stand by two flat steel collars. Use a grooving hammer to make a groove in the middle. Before the collar is applied, join the two spirals to the stand with welding points, which makes it much easier to mount the collar.

Attach two scrolls above the two spirals in the same way as the volutes.

Forge the stand round toward the point and attach a spiral on top. The spiral can be fastened on by brazing or welding.

Make two more hooks of square steel, with a side length of 0.24 inches (6 mm), to hang up pots or artistic pieces.

Hammered surface of the bottle opener handle

Workpieces Forged from Scrap Metal

There is a special appeal to giving used tools and devices a new life through forging. The work described below was done by master smith Gerhard Gissing.

Design of the volutes

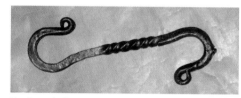

Hook made from a square steel bar

Knife Made from a Worn-Out Power Saw Chain

Power saw chains are made of three different things: drive chain links, sprocket teeth, and rivets. These three parts can be welded together by fire welding and formed into a compact block. This process creates a structure similar to that of Damascus steel.

Break up the power saw chain and lay the pieces out in approximately the form of a knife, making the blade portion thicker. To have the chain retain its shape during heating, fasten the chain links together with a few welding points.

Heat the power saw chain (the workpiece) to white hot and sprinkle it with a flux

Garden volute stand of round steel

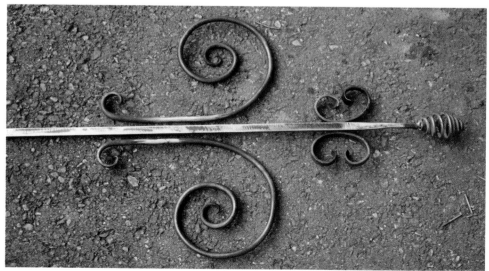

Elements of the garden volute

(borax). Now put the workpiece back in the fire, so that the flux forms a glassy coating. Take the workpiece off the fire when it reaches a high temperature. The chain is upset-forged by powerful hammer strikes. Repeat this process as long as it takes, until there are no more hollows.

When the blade portion for the knife is completely welded, this section becomes folded together. To do this, make a notch in the center of the blade portion with a splitting hammer, so that the section to be bent is clearly delimited when you do the bending.

Then sprinkle the folded section with flux again and fire-weld it. Forge the blade portion thin on one side. The area for the handle is also fire-welded, but just to the extent so that it retains the structure of a power saw chain. The blade shape is created by abrasive cutting.

Use mechanical processes (grinding, filing, sanding, and polishing) to bring the knife into its final form.

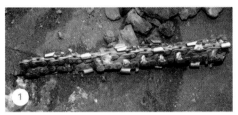

Parts of the power saw chain fastened together with welding points. The handle (*on the left*) is one layer; the blade portion (*on the right*) consists of two layers.

Knife Made
from an Old Steel Cable

Steel cables are made of high-quality steel and therefore also work well for making

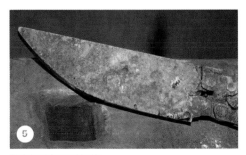

Welding the blade portion for the knife made from the power saw chain

Notching the area for bending the blade portion

The knife gradually takes shape. There are still uneven places on the blade portion surface.

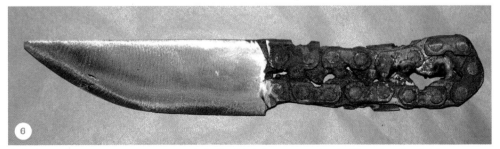

Finished forged knife

Knife forged from a worn-out power saw chain. The blade is preground and still needs a fine finish.

knives. The challenge for the blacksmith is welding the cable wires together by fire welding. The blade portion should yield a compact piece without any inclusions.

The starting material is a piece of steel cable with a diameter of about 0.8 inches (20 mm). You can assume 9.8 inches (250 mm) as a guideline for the length. Weld the steel cable at both ends so that the individual wires cannot come loose.

Then heat the steel cable to forging temperature and compact it by twisting in the direction of lay.

Sprinkle the compacted steel cable with flux, heat it, and forge it flat. Since it would be too thin in this condition, the forged area is folded together. To obtain an exact bending line, use the splitting hammer to hammer in a notch at the bending point. The flat section can be easily bent over at forging temperature. The folded-together piece must be welded well. Again, this is done by fire welding.

After welding, the blade is shaped. In this process, the workpiece is forged into a wedge shape. Use an abrasive cutter to cut the blade portion to length. Cut off the excess piece at the point of the knife likewise.

Work the surface with roughing, finishing, and sanding disks to create a smooth surface.

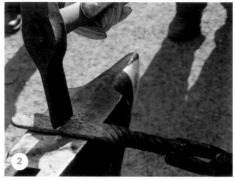

Twisting the steel cable in the direction of lay

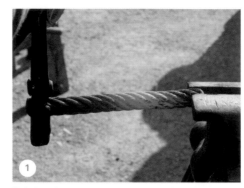

Notching the flat forged piece

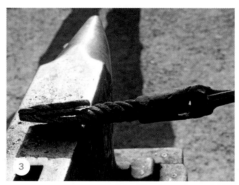

Folded-together piece for the blade

Applying the flux for fire welding

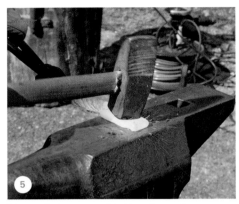

The two halves are welded together, using powerful strikes.

Forging the blade portion to a wedge shape

Grinding the blade of the cable knife

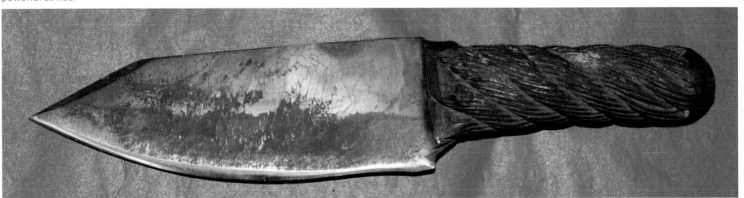

Knife made from an old steel cable

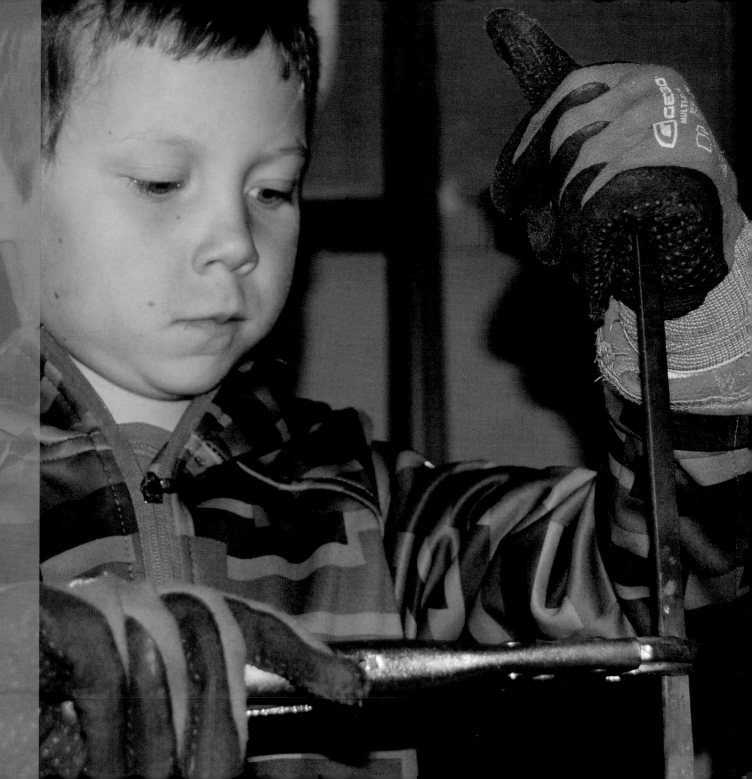

CHILDREN AND HOT IRON

Children's Enthusiasm for Forging

Many events feature forging demonstrations. In some places there are demonstration smithies, which are run as an attraction for vacationers. Of course, they also arouse the interest of children, especially working with fire and the red-hot iron and steel. With the

Victoria, the author's granddaughter, with a nail she made in the exhibition smithy, and her certificate for it.

Left: The small blacksmith is twisting a flat bar with the help of griping tongs.

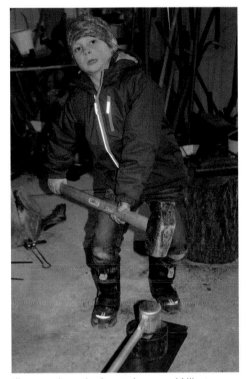

Klemens, the author's grandson, would like to forge a bowl by using a die and a sledgehammer. At right in the picture is his small anvil on a low wooden block.

guidance of expert personnel and, above all, while taking all necessary precautions, children may be introduced to the work of the blacksmith. Children can make single parts for simple forging work, but children should not use machines; it is not a good idea for children to use heavy hammers and large tongs. In the demonstration smithy in

Spital am Pyhrn, Upper Austria, visitors can forge a nail and get a certificate for it.

Besides the safety aspects, when working with children you must above all be particularly aware of their bodily physique. It should also be possible to make the workpieces in a short time, usually with the help of their parents.

Thermometer Holder

As an example, we describe here how to make a holder for a thermometer. So as not to cloud the joy in the work, don't set expectations for the quality of the work too high. This holder is made of flat steel with a

Side pieces for the holder

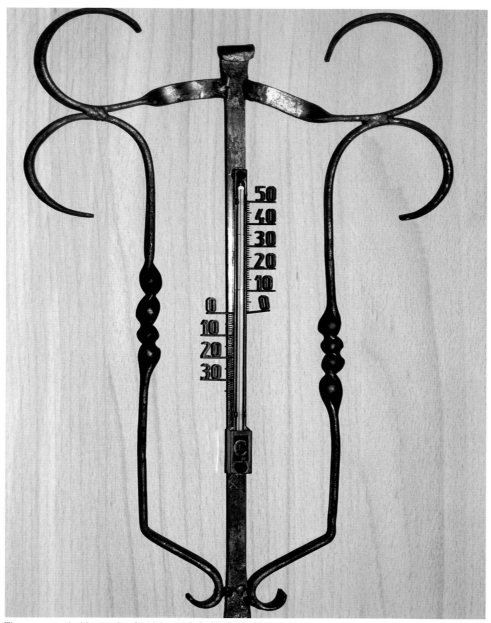

Thermometer holder made of 0.12-by-0.4-inch (3 × 10 mm) flat steel

cross section of 0.12 × 0.4 inches (3 × 10 mm). It primarily involves bending and twisting work. It could also be made in cold work because of the material's small cross section.

Heat the flat bars to forging temperature and twist them in the middle area by two to three revolutions. This requires little expenditure of force; problems arise when clamping the piece in the vise and guiding the locking pliers as straight as possible while twisting.

After the twisting work, bend and angle the bar ends over a cylindrical stake. The upper crosspiece is made the same way. With this, most of the "child's work" is done.

The center piece is spread and curled at the end of the bar. All parts are brazed or oxyfuel-welded. The last part is to make the holes for holding the thermometer and to mount the thermometer.

In this chapter we present interesting forged works, in a loose order.

Grating on a chapel in the Dolomite Mountains. This type of grating is not typical for a church grating. The individual elements were not made very exactly.

Church grating in the Dolomites. Only one volute shape was used for this grating.

Grating on the gate of the dilapidated Mt. Calvary church in Bruck an der Mur, Styria. The grating elements are bent in a sharp-edged way and are decorated with scrolls on the collars. The side supports are decorated with flower elements. The upper frame contains leaf elements.

Typical form of grating, as used in sacred buildings, palaces, and similar buildings. The rounded shape of the bars suggests that no template was used for bending.

Window grating on St. Stephen's Cathedral in Vienna. The special feature of this grating is the twisted bars in the middle. The bars are either straight up to halfway or punched. This creates four segments, which do not stand out at first sight. The same segments are arranged diagonally each time.

Window grating on the city parish church in Bruck an der Mur, Styria. The central area of this grating is decorated with scrolls. There are similar decorations on the gate of the Mt. Calvary church in Bruck an der Mur.

Window grating of punched bars. The bars are punched in such a way that the grating cannot be taken apart after it has been finished.

Top of the Iron Fountain

The Iron Fountain's hemispherical dome (see also a larger picture on page 133)

"Iron Fountain" in the main square in Bruck an der Mur, Styria. This seventeenth-century fountain structure contains artistic and elaborate blacksmith work.

There are different types of figures and embossed designs in the wrought ironwork on the Iron Fountain. The metal pieces have been repeatedly painted over, so that over time the fine detail became unrecognizable. It became possible to see these fine features again only after an expert restoration.

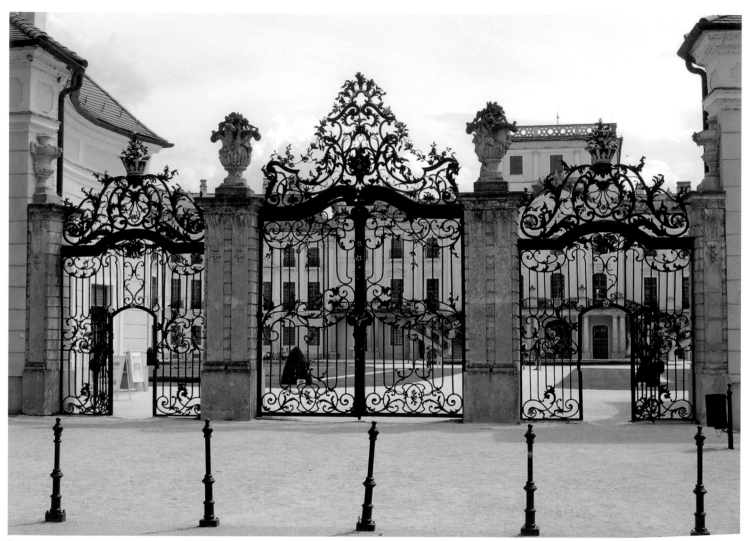

Entrance gate to the Esterházy Palace in Fertöd, Hungary. Magnificent forged works can be found throughout the palace complex. Similar designs can be found in the Schönbrunn Palace in Vienna.

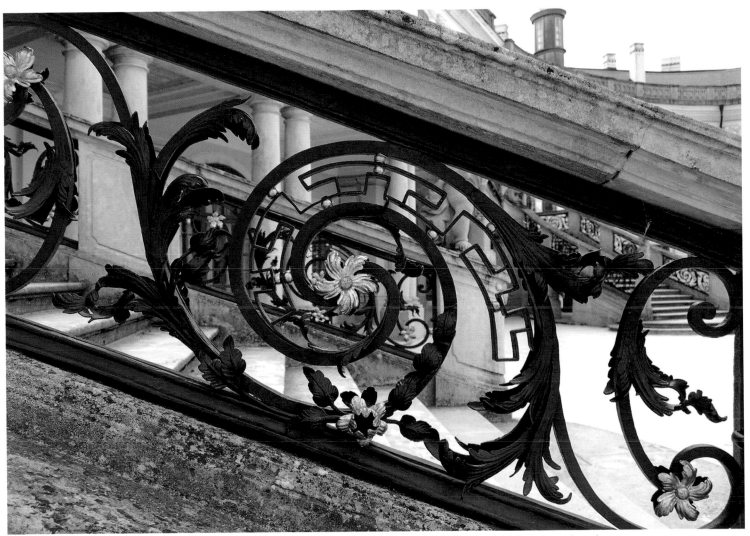

Staircase of Esterházy Palace in Fertöd, Hungary. The railing is made of volute-shaped square bars; flower and leaf designs are riveted on.

Gate lock at Esterházy Palace in Fertöd, Hungary. The rivet joints on the bars can be clearly seen. The lock piece is screwed on to make it possible to dismantle the lock.

Door hinge on an old church door

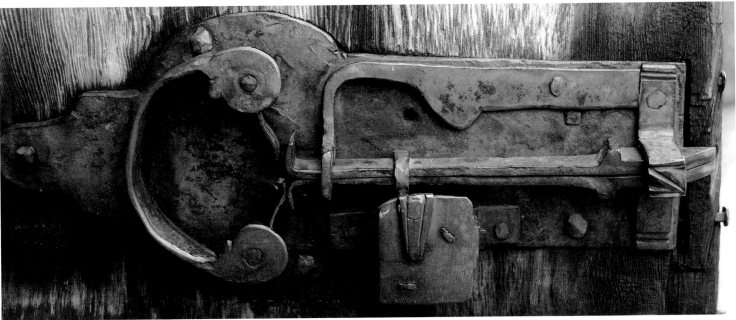

Door lock on an old farmhouse in the Austrian Freilicht (Open Air) Museum in Stübing, Styria. The bow at left holds the springs for the catch.

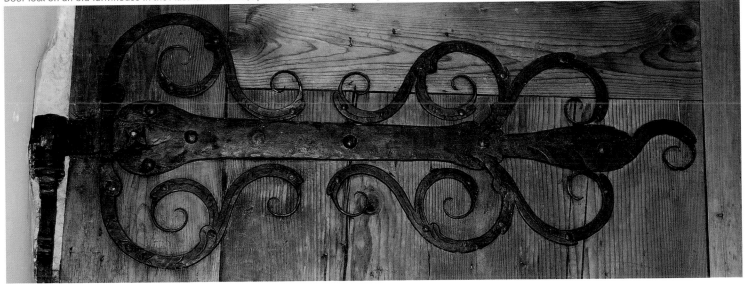

Door hinge on a door on Vorau Abbey, Styria

Door hinges on a Norwegian stave church, southern Norway. Unfortunately, the door handle does not correspond to the overall picture.

Forged-metal door fittings on a Norwegian stave church, southern Norway

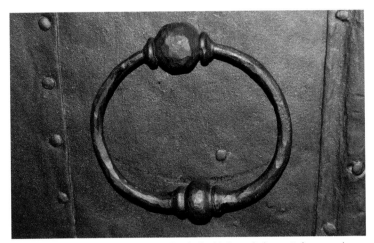

Door handle on an old church door. The ball with lateral elements is a popular design in artistic forging.

Curved window grating on a restored mansion in Spital am Pyhrn, Upper Austria

Grating in the Abbey Church, Spital am Pyhrn, Upper Austria

Curved window grating on a house in Windischgarsten, Upper Austria

145

Curved balcony railing on a house in East Tyrol
(*top*) and side view of the curved balcony railing
(*left*)

Curved window grating of scrolls and flower elements

Side view of the curved window grating

Grating in the Abbey Church, Spital in Pyhrn, Upper Austria

Grating on a *Marterl* (niche holding a cross) in the Austrian Freilicht (Open Air) Museum in Stübing, Styria

Grating on a *Marterl* (wayside cross) in the Austrian Freilicht (Open Air) Museum in Stübing, Styria. Flowers designs and leaves are incorporated into the ends of the volutes.

Grating made mostly of volutes in a church in Ribe, Denmark

Guild marks on a hotel in East Tyrol. Forged guild marks are usually elaborately designed. Unfortunately they are often marred by advertising signboards.

Detail of a forged grave cross

Ball as a connecting element between two volutes

Volutes fastened together by a collar on an entrance door in Riva, Italy

Elaborately fashioned joins

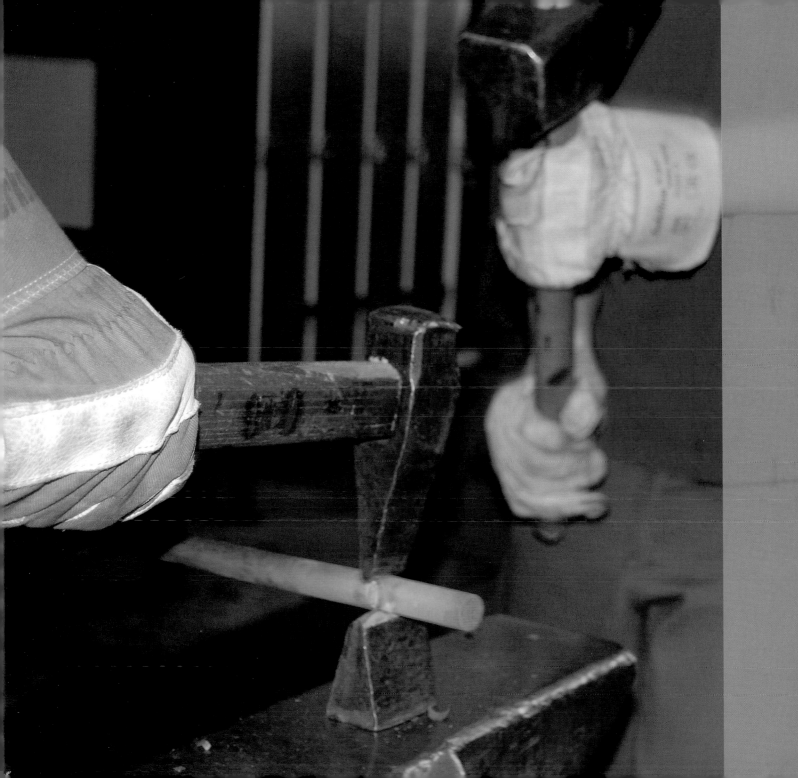

Glossary

air hardening: Steel that is already hardened when air cooled due to its alloy elements

alloy: Combination of several metals to achieve certain properties

annealing: Heat treatment that eliminates internal stresses, for example

anvil: Important forging tool; very heavy. The forging work is done on the anvil.

anvil face: Top of the anvil

austenite: Structural designation. Austenite can absorb carbon atoms in solution and can be forged well.

axe: Tool with cutting edge and impact head, also referred to as a *Hacke* in Austria

bending fork: Tool for hot-bending round workpieces

bending jig: Tool for repeatable bending of workpieces, such as volutes

blind hole: Hole that does not go all the way through a workpiece

bloomery: Historical furnace to make pig iron

borax: Agent for fire welding

brazing: Joining method for metals with brass or silver solder

Bröckel (Austrian term for "chunk"): Steel bar for starting material for an axe or a sappie

calibrate: To measure dimensions precisely

cast iron: Iron-carbon compound with more than 2.06 percent carbon content. Is not deformable.

cast steel: Steel case in a form. Can be further reshaped.

cementite (Fe_3C): The metallographic name for iron carbide, which is hard and nondeformable

ceramic chips: Ceramic pieces the same size as forge coal for use in gas forges

chilling brittleness: Very high degree of hardness of a workpiece, which can crack like glass under impact.

chip removal: Machining by chip-removing processes, such as turning and milling

chisel off: Cutting off a workpiece with wedge-shaped tools, usually when red hot

clamp: Popular term for a cramp iron

collar: One method to join forged parts

constant volume: When forging, the volume of the workpiece remains constant.

corrosion-resistant steel: Steel with at least 12 percent chromium content. Will not rust.

countertwist: A bar is twisted once to the left and once to the right.

crimping: Two intersecting bars are shaped so that one side of the cross lies flat.

crystal lattice: Atomic arrangement of the iron and carbon atoms

Damascus steel: Steel made of several layers of different steels that are fire-welded together

die: A form that incorporates the geometry of the workpiece to be made

drop forging: Forging process in which the shape of the forging piece is determined by the die

even heating: The workpiece is at the same temperature throughout the entire cross section.